Also by Tom Lubbock

Great Works: 50 Paintings Explored
Until Further Notice, I am Alive

ENGLISH GRAPHIC

TOM LUBBOCK

F

FRANCES LINCOLN LIMITED

PUBLISHERS

Frances Lincoln Limited
4 Torriano Mews
Torriano Avenue
London NW5 2RZ
www.franceslincoln.com

A catalogue record for this book is available from the British Library.

978-0-7112-3370-6

Printed and bound in China.

1 2 3 4 5 6 7 8 9

Edited by Marion Coutts.

CONTENTS

6 Introduction

16 The Uffington White Horse
20 Hellmouth
24 Mappa Mundi
28 Two English Maps
32 The Bishop's Eye
36 Portrait of an Unknown
 Man Clasping a Hand
 from a Cloud
40 Leviathan
44 The Flea
48 Fantasy of Flight
52 Characters and Caricaturas
56 A Complete New System
 of Midwifery
60 Fuseli to Frankenstein
68 A Blot: Tigers
72 A Foregathering of
 Witches
78 Ambleside
82 The Source of the Arveiron
86 The British Slave Ship
 'Brookes'
90 Mending a Face / Marring
 a Face
94 The Face of the Moon
98 The Gout

102 A Democrat
106 Electra and the Chorus
110 Blake Shapes
118 Jerusalem The Emanation
 of the Giant Albion
122 Albion Rose
126 Defining the Vignette
138 Vision and Landscape
144 In a Shoreham Garden
148 A Fantasy: The Fairy Ring
152 West Bromwich Sweep
156 Alice Overgrowing the
 Room
160 Portrait of Himself in Bed
164 Mr Aubrey Beardsley
168 Sower of the Systems
174 The New Word in Golf
178 The London Underground
 Map
182 Red Figures Carrying
 Babies and Visiting Graves
186 Fragments 6/9
190 The Hermit
194 For the 5 Vowels

201 Index
205 Editor's Note
207 Acknowledgements

Francis Quarles, frontispiece to *Hieroglyphics of the Life of Man*, c.1637

INTRODUCTION

By Jamie McKendrick

The word 'graphic' in the title – let's leave the 'English' for now – comes from the Greek *graphein*: meaning both to write and to draw. Although the word commonly refers to a range of media including sketches, prints and illustrations, we are right to think of it as largely concerned with the linear rather than the plastic, with tone rather than colour. In Tom Lubbock's hands the term becomes still broader and more flexible – earthwork, rose window, Tube map, watercolour – but in each case the reason for the inclusion becomes immediately apparent. In his chosen examples, as well as in his treatment of them, this link between writing and drawing is reinforced. Frontispieces and illustrations declare their relationship with text, and maps also conjoin word and representation, as do cartoons with their captions and speech bubbles. All of these show a kind of hybridity in the art form, the instability of one thing becoming another, and in his concern with outlines and boundaries, Tom's enquiries again and again attend to such protean aspects of the image.

Blots, dots, lines, marks and so on all have a writerly aspect, a dual identity, and in this collection of his writings especially, Tom makes numerous sorties into literature and philosophy to 'illustrate' the chosen image or rather to think along parallel lines about it. He draws on a vast store of poetry – Racine, Beddoes, Hopkins, Eliot, Les Murray and many others – as if to disrupt the frontiers established between the art forms, but also because he sees such disruptions as being inherent in graphic art. To take just one instance, he compares what he calls a reaching-out effect in Keats's poem 'This living hand' to *A Democrat*, Gillray's caricature of Fox with his blood-drenched hands. The mutual illumination is extraordinary, even shocking, given the opposed political sympathies of these two contemporaries. This reaching-out effect, with the switch to plainer English which Tom observes in Keats's poem, is also a noticeable and frequent effect in his own writing about art: the sudden palpable presence of the speaker.

In the proposal for this book he described the project: 'The connecting and overlapping ideas running through the book are: maps; islands; whales; clouds; enclosures; multitudes; swarms; wombs; contours; vignettes; creations; visions; miniatures; skins; containers; outlines; rows; lines; dots.' The items on the list

are very intricately connected, and those connections emerge and re-emerge, like islands – an archipelago – or whales, or schools of isles. Clouds are sky islands, 'sometimes dragonish', sometimes 'very like a whale'. 'My island seemed to be / a sort of cloud-dump' as Elizabeth Bishop writes in her poem 'Crusoe in England'. Even the shapes of Bewick's vignettes take on an islandish contour: 'the coastlines of these ovals can be very rough and fluctuating.' Here, as elsewhere, the prose assumes something of the delightful play of a Francis Ponge prose poem – with sudden illumination the contours of the artwork, and how we perceive it and the world beyond it, are imperceptibly shifted.

Swarms and crowds, crushes and clusters, hives and cells are other important strands in this work – a matrix of imagery. These concepts allow him to navigate between Hogarth's 'hugger-mugger' hundred *Characters and Caricaturas*, the frontispiece of Hobbes's *Leviathan*, its colossus crammed with a populace, the flying figures in Carwitham's astonishing drawing, Palmer's blossom-crowded trees and a host of other pictures that would include the dots in a Bridget Riley abstract. The slave ship *Brookes*, in one illustration, is the most infernal crowd scene devised by economic greed.

Tom is a great reader of images – by this I don't mean to suggest his approach is an especially literary one but that his interpretations are acts of attention to what the marks on the page do as well as mean, and how that affects the way we respond to them. Always a significant part of what he looks for is what it tells us about the *ways* in which we look. Often enough he proposes a series of readings of a given shape, alert to its alternations and possibilities – just to give one example from his description of Lincoln cathedral's rose window: 'like planets in orbit, spokes of a wheel, radiant beams, exfoliating petals'. 'The eye altering alters all,' as Blake, one of the crucial figures in Lubbock's pantheon, writes in 'The Mental Traveller'.

Part of his concern with the protean is the question of how we perceive, but it is just as much a look at the artist's own potential for generating these perceptions. His essay on Romney, for example, is a masterly reassessment of a neglected artist but also a remarkable account of an explosive moment in which Romney

alights on a black-and-white storyboard technique that surpasses and outstrips everything he has elsewhere achieved. Here Lubbock is keenly aware of what this, possibly a cul-de-sac for the individual painter, might lead to in the hands of future artists ('He inspired Blake but lacked Blake's inspiration').

Like *Great Works*, the first selection of Tom Lubbock's writings, but with a more tightly focused topic, this book has largely been compiled from the Great Works column Tom wrote on a weekly basis for the *Independent*. The constraints of the form proved exceptionally viable and liberating for his procedures. Providing a 'wiry outline' (Blake's phrase), the form itself allowed for wit, aperçu, mental callisthenics, provocation, aphorism, meditation and surprisingly sustained argument. It means leaving the starting line at some velocity – and Tom developed some really stunning openings: 'Images are mostly not for looking at. They are for being there and having around' and 'You can be in two minds about the moon' are two of my favourites. But the pieces are never content to be merely eye-catching: they have to examine both the picture and their own premises; they have to advance a line of thought; and – here Tom also excels – suggest how it might develop. This is another gift to his readers – a spur to do it themselves, to see where the thought leads. The longer essays that are included in this book are a special bonus, because there we can see how this compactness could unfold on a larger canvas. We see how able Lubbock is to extend and deepen the insights that abound in his shorter pieces.

Another strand skilfully worked throughout this book has to do with bodily sensation, with the skin which is both a 'container' and our largest sensory organ. We see its vulnerability in Gillray's cartoon *The Gout*, and in Thomas Rowlandson's *Six Stages of Marring a Face*. We see it too in the anonymous folk artist's *West Bromwich Sweep*, where the boxer's horribly battered face prompts a rebuke to Hazlitt's bloodthirsty paean to pugilism. But, more extensively, the physical experience of space, or lack of it, is examined with wonderful clarity in John Tenniel's illustration of *Alice Overgrowing the Room* as well as in the cramped and curled figures in Fuseli and Blake, set against the latter's 'starfish' Albion, stretched (almost) to his human – and spiritual – limits. Lubbock's alertness to the devices

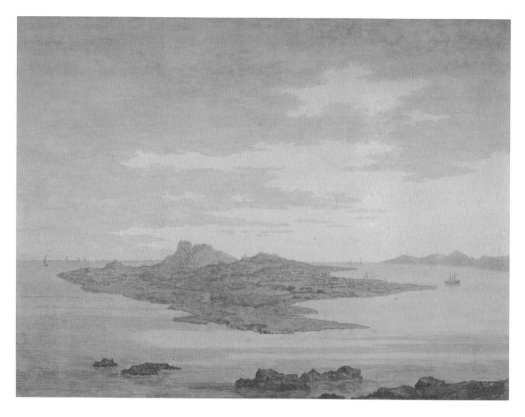

Alexander Cozens, *A Rocky Island*, *c*.1785
Pen and brown ink and wash on tinted paper, 46.3 x 62.4 cm
Whitworth Art Gallery, University of Manchester

of 'framing', exactly where the picture ends, is a key and recurring element in his analyses – how our experience of space can be tampered with and unbalanced by the fronded edge of a Bewick vignette or by the subtle cropping of the left-hand margin of John Russell's *The Face of the Moon*.

What of 'English', then? *English Graphic* has no nationalist agenda, and it doesn't seek to impose a set of national characteristics. Unlike, say, R. H. Wilenski in *An Outline of English Painting* (1946) where there is a somewhat anhedonic argument for English art's persistent moralism, or even the far more subtle and observant Nikolaus Pevsner who speaks of the 'flaming Gothic line' in *The Englishness of English Art* (1956), the idea of a set of family resemblances doesn't seem to hold much interest for Tom. Although at one point he declares that 'the

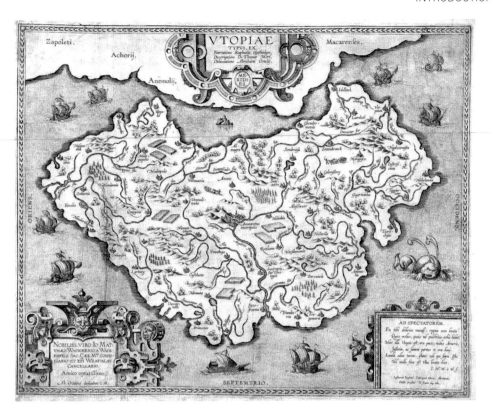

Abraham Ortelius, *Map of Utopia*, for Thomas More's *Utopia*, c.1595

tradition of English illustration has typically been devoted to the fantastic and visionary', in another piece – on Samuel Palmer – he amusingly takes a scunner to this second term. But still there are lines and lineages (or 'lineaments' as Blake might say) – strands that become skeins and, beyond this, recurring arguments. One such central argument is between the visual and the visionary, between reality and imagination. It is rehearsed in the wonderful piece on Hooke's flea from *Micrographia* where Lubbock commends the actual over the chimerical: 'We often take imagination as the great achievement of art. But the refraining from imagination can be just as great and often harder. What we see in *The Flea* is the discipline of observation.' (If only we had Tom's thoughts on Blake's *Ghost of a Flea*, a macabre twin.) Again, in the contrast he draws between Bewick

and Blake: 'His images are more faithful than Blake's are to "minute particulars", both in their knowledge of nature's details, and in their mastery of engraving at a miniature level. Their wonder lies, not in vision, but in eyesight.' Though this may seem like an argument for a stolid English empiricism, it is only half the story. It is part of an unresolved and creative dialectic and needs to be set beside his passionate appreciation of Blake's visionary imagination: 'Blake's great artistic discovery was the potentialities of two-dimensional life. No artist before him understood so clearly the uses of the flat page to create a transcendental world, a world in which things are simultaneously material bodies and spiritual forces.' His two pieces on Blake's illuminations are among the most brilliant and searching readings both of the images and of the artist who forged them.

Lubbock makes few references to art critics and historians, and often then just to show them the door. 'Wrong,' he says to Panofsky, Rosenblum and James Hall. On another occasion, he makes fun of 'all the I-Spy stuff commentators on Hogarth like to go on about'. Baudelaire and Robert Hughes, however, receive a brief but warm welcome. This absence may be due to the constraints of space, but I think it's also very much of a piece with his whole procedure. Tom approaches pictures without the armoury of the specialist – it's an open engagement, *mano a mano*. Iconographical and historicist studies are not likely to appeal to a writer who delights so much in provocative anachronism – but anachronism, as he argues persuasively, is unavoidable in how we look at art: 'since we never shed our contemporary selves, anachronism is the air we breathe'. Unavoidable, and also fertile. He plays with this notion by uncovering the seed of abstraction nascent in a Townes watercolour, the invention of collage in the random reassembly of a medieval rose window, and the foreshadowing of abstract municipal sculptures in H. M. Bateman's *The New Word in Golf*. More generally it is present in the way he traverses, backwards and forwards, vast tracts of art history, finding precedent and prolepsis.

One fuller engagement that does occur is with the critic John Berger, and his description of Samuel Palmer's paintings as being like 'furnished wombs'. It's an expertly loaded phrase – straight off you can see the damage it intends:

Palmer has made the natural artificial, made his nature cosy, bourgeois, acquisitive. Why is he painting these little idyllic retreats at the height of the Industrial Revolution? What the phrase excludes is the way that the womb-like curves and swelling forms of Palmer's work, down to the embossed surfaces heightened and glistening with gum Arabic, are a true and valid modality of perception. And while Tom doesn't explicitly quarrel with the phrase, his description of the effects of Palmer's paintings – how the flowering branches are 'not so much blossom as like a shaggy fleece, or bubbling foam, or proliferating fungus growths, or clusters of pearls' allows the pictures to reply in their own terms. These alternative readings are superbly responsive to Palmer's own description of his surfaces 'sprinkled and showered with a thousand pretty eyes, and buds . . . and blossoms, gemmed with dew', albeit in a less conventional poetic style. But the ultimate rebuttal to Berger's critique comes in the sure judgement which Lubbock arrives at: 'Palmer believes in individuality to the end. Every bit of creation has its iconic character, distinctly outlined.'

As Laura Cumming notes in her introduction to *Great Works*, John Berger is almost the only art critic with whom Lubbock can be compared. Both have a rare and robustly independent cast of mind and give short shrift to cant and specialist jargon, and both have, and communicate, a joy in arguing. But Lubbock has no political design on the reader. Paradoxically that may make him the more radical: he works on the body rather than the body politic.

The revelation of Tom Lubbock's Great Works series, and one borne out by all his art criticism, is how much there is in every painting to think *about*, even to think *with*; how much thought – not just instinct, luck or genius – went into the making of a picture and, in generous exchange, how much thought each picture prompted. It is a grievous loss that he is no longer here to add to these thoughts, but this book is a celebration of his singular gifts.

ENGLISH GRAPHIC

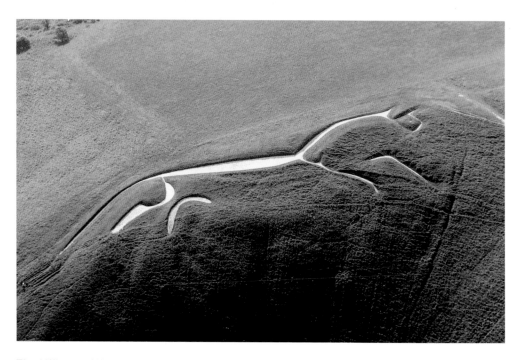

The Uffington White Horse, Oxfordshire, dating from the Bronze Age

THE UFFINGTON WHITE HORSE

Things change. The ancient historian Plutarch cites the ship of Theseus. After the hero's death, it was put on permanent display in Athens. Over time, its timbers rotted, and were replaced. Eventually they were all replaced, and 'being so refitted and newly fashioned with strong plank, the ship afforded an example to the philosophers in their disputations concerning the identity of things that change.' Some said it was still the same ship; others said it wasn't.

It sounds like a semantic question – it depends what you mean by 'same'. But it needn't exclude feeling. Later Athenian tourists might have been disappointed to find that they couldn't touch a real bit of history. And when renovation involves alteration too, it can become a highly sensitive issue. Think how bothered art-lovers get when restoration work goes too far.

In his lifetime, Giotto's most famous picture was a mosaic in St Peter's, known as the *Navicella* – the ship. Made around 1300, it showed the disciples of Jesus in a boat, in a storm, with Jesus standing on the water, lifting up St Peter as he sinks. If you go to Rome today, you can still visit this mosaic. But hardly anyone does, because it's been restored beyond all recognition.

In principle a mosaic can be repaired pretty faithfully. It's made of pieces of coloured glass, and when one drops out it can be substituted. But that's not how the *Navicella* fared. It suffered centuries of disintegration and damage (due to being removed and relocated). When, in the late seventeenth century, it was put up where it now is, in the rebuilt St Peter's, it had been repaired so radically that almost nothing of the original design remained. You can see this by comparing it with a drawing made of its earlier state. You can see it in the style. Giotto's *Navicella* survives in name only.

Does that matter? It depends on how you value images. If you live in an art-world like ours, where authorship and handiwork are prized, then the fate of the *Navicella* may seem tragic. As far as we're concerned, the image – Giotto's image – has ceased to exist. But if you live in an art-world with different values, where images are prized above artists, you may disagree. Your priority will be to maintain an image in a functioning state, even if not in its authentic state.

Modern restoration policy favours authenticity. If an area of a fresco is completely lost, we don't replace it with our own guesswork. We leave it blank. Traditional restoration policy believed in maintenance. An image should be kept up. A picture cannot perform as a picture with a great blank in the middle of it. So if a part is lost, we should fill it in as best we can. On those terms, the renovators did the *Navicella* proud. They kept it going.

There are some images, though, that don't just need a patch now and again. They have to be kept up all the time.

The Uffington White Horse is the oldest of the chalk figures cut into the hills of southern England. Recent archaeology dates it to the Bronze Age, but its beginnings remain mysterious. It might have been made as a tribal banner, a battle memorial, a cult symbol, even a horse traders' advertisement. The hundred-metre-long image is only comprehensively viewable from the air, so how it was first marked out on the ground is a poser. With its beaked birdlike head, and its detached freeform limbs, it may look strangely familiar to the modern viewer – suggesting a Picasso graphic or a Matisse cut-out. But what form it originally took is another unknown.

There is no written record of it before the twelfth century. There's no depiction of it before the sixteenth, and no informative likeness before the eighteenth. But the horse was never forgotten. The grass grows over it quickly. To be maintained, it must be scoured about every ten years. Throughout its long history, the horse was kept going by regular renovation work, done by the local population.

There was no question, therefore, of preserving the original handiwork. In order to survive at all, the horse must be continually re-cut. And without any master blueprint, there wouldn't have been much chance of holding on to its original shape either. With successive scourings, some kind of Chinese-whisper image mutation is unavoidable. Change is the condition of endurance. The various drawings of the horse made in the eighteenth, nineteenth and twentieth centuries may suggest that its outlines drifted significantly, even during that short portion of its existence. The head in particular seems to undergo drastic transformations.

On the other hand, perhaps it didn't change so much. These variations in the record may only reflect vagaries of draughtsmanship. The horse is hard to view properly, and to a non-twentieth-century artist it would have seemed an alien shape, hard to draw. And unlike other chalk figures, this horse is not just a surface turf cutting. Its makers laid down a metre-deep chalk-filled trench under it. Not all the scourings would have followed this 'skeleton' – the trench's existence may not always have been known – but it exerted some control on the tendency to drift.

While the horse may have strayed down the centuries, it has certainly retained its identity better than the Westbury White Horse, in Wiltshire, which was wholly redesigned in a modern style in the late eighteenth century. The Uffington Horse has probably never wandered very far from its first appearance. Still, what that was exactly, we can't tell.

It doesn't much matter. The Uffington White Horse is a classic case of a 'maintained' image, where upkeep takes precedence over authenticity. There is the relay of scourings, linking back three thousand years, but like its original appearance, its original *raison d'être* is also long lost. The figure is now preserved, as it was for most of its history, presumably, as an iconic landmark and a notable antiquity. It's something that must be continually renewed, simply because it has always been there – and in the process constantly modified! It is the very image of a *tradition*.

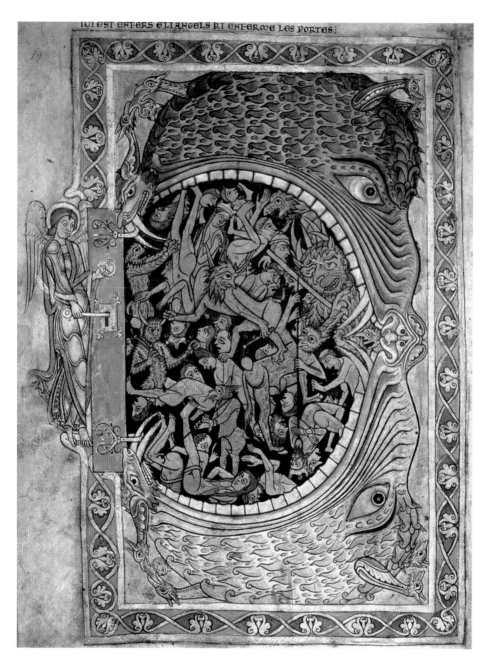

The Damned are Swallowed by Hellmouth from the Winchester Psalter, *c*.1121–61
Ink, tempera and gold on vellum, 32 x 22.25 cm
British Library, London

HELLMOUTH

It's one of the simplest and most basic pictorial acts. You draw a line round so that it meets itself and makes an enclosure. The line is now an outline, a boundary. It makes a border between an inside and an outside. It creates a defined space, a distinct shape – which is possibly going to become something, like a face, an eye, a mouth, a body, a cloud, an island, a lake, whatever. But marking out a surrounding limit, fencing off an area, that's the first step. Enclosure can even be a source of drama in itself.

In the medieval imagination, the mouth of Hell was often pictured as a real mouth. It was the mouth of a great beast, a sea creature, a whale, Leviathan. Hellmouth is the name of this image, and it appeared in many different forms. It might be constructed as a piece of scenery in a mystery play, or carved in stone on the tympanum of a Romanesque church, or painted on church walls, or in manuscript illuminations.

Several biblical texts inspired this idea, though there is no unequivocal scriptural authority for it. Its hellish appeal is clear. The creature is monstrous and slimy. Its mouth is a dark and cavernous prison. It is toothed and ever hungry.

And in other ways, a mouth is a good metaphor for Hell. If you're in the process of being eaten, you aren't killed outright, your body is transformed bit by bit into edible matter; like the damned, you are alive and dead together. And because a mouth can chew on a piece of food or non-food almost indefinitely, chewing is a good image for the interminable and continuous torments of Hell. The lost are masticated forever, eternally eaten alive.

When it appears in pictures, Hellmouth is generally little more than a mouth, a face without a body, a pair of jaws plus eyes. It appears in Dooms – Last Judgement scenes – at the bottom. It is wide open like a man-trap, a gaping cavity into which the souls of sinners are shown tumbling and being prodded and shovelled by devils.

What makes it especially monstrous is that it is not a fully living creature. It's a detached organ, with a reflex action, a bit of flesh that blindly pursues its bodily function though separated from an active body. This is a motif familiar from horror films – the severed hand that still grasps, the plucked-out eye that

still sees. The huge mouth that munches on automatically is as damned as any of the damned it consumes.

There's a similar notion in Dante's *Inferno* (though Dante doesn't use the Hellmouth image as such). Satan, lying at the bottom of Hell, is an automaton, a giant animated corpse, whose three mouths perpetually, mechanically chomp on the bodies of the worst sinners, 'like a mill'.

Now with Hellmouth, as with Hell itself, you can see things in alternative ways. You can stress how easy it is to get in – or how hard it is to get out again. One way, Hell is a constant danger, always open. The other way, Hell is a closed trap. The majority of Hellmouth images show an open mouth, with the damned falling in. But in this picture, a page from the Winchester Psalter, the mouth is closed.

This is not a Last Judgement image where the infernal maw lies on its back, open to all. The mouth here is turned sideways, and the stress is on containment. The episode illustrated is from the very end of the history of everything, when the saved and the damned have conclusively been separated, and the angel comes down and locks the jaws of Hell. *Ici est enfers e li angels ki enferme les portes*; here is Hell and the angel who closes the gate: so says the little caption along the top of the image in oldish French. It's all over. No one else will ever go to Hell, that's the idea. But of course what the *image* emphasises is that no one will ever get out.

The interior of Hellmouth is shown, not as a voluminous cavern, but as a two-dimensional area, a D-shaped enclosure. To be inside the mouth is to be inside this area, and the power of the image lies in that equation. Corralled within are the naked human damned (among them kings, queens, monks) mixed up with horned and hairy demons – a melée of figures clearly delineated against a dark ground. They are pressed together within this mouth area as if they were all lying on the same flat plane, like coins in a 'penny falls' slot machine, shoved edge to edge, sometimes overlapping, and ringed in by the curving walls of teeth. The experience of being crammed into a mouth is vividly displayed, in cross-section so to speak.

It is terrifying. In 1789 a similar device was used as propaganda to great moral effect. Devised by Thomas Clarkson and other members on the Committee for

the Abolition of the Slave Trade, the image was called *Stowage of the British Slave Ship 'Brookes' under the Regulated Slave Trade Act of 1788*. It was a diagram, and it was highly successful. It depicted how the slaves on their passage across the sea were compacted flat into every available space on deck. To be in this waterborne hell was to have a two-dimensional existence, unable to rise, and to be confined, packed tight as cargo.

As often in illuminated manuscripts, the edge of the image itself is made part of the image. The angel who turns the key stands outside the oblong picture, in the blank margin of the page. The lock more or less coincides with the decorative border. The frame of the image is equated with the outer limits of Hell. Hell is hemmed into its page. The angel arrives from another realm.

And within this bolted Hellmouth, the torment and pressure go in two directions. The figures in the mouth are like sardines, cramped and crushed together. But equally they're like gobstoppers. Turn the page round and look at the monstrous scaly beast-face itself, torn apart into its upper and lower halves. Look at the stretch marks round the lips, the boggling eyes. You see a mouth that's stuffed with more things than it can hold, and locked shut, gagging eternally on its unfeasible mouthful. It's hell, being Hell.

Anonymous, of course. This masterpiece of Romanesque graphics, like every image and carving of its time, can be credited to no individual author. The Winchester Psalter is usually thought to have been made for Henry of Blois, Bishop of Winchester, in the middle of the twelfth century. It contains thirty-eight pages of miniatures illustrating the Old and New Testaments, painted by unknown craftsmen in ink, tempera and gold on its vellum pages. Hellmouth is its most powerful and most popular image. The subject of Hellmouth persisted in art until the seventeenth century. In *The Adoration of the Name of Jesus*, El Greco depicts Hell as a gaping whale. And the term itself is still well known to fans of *Buffy the Vampire Slayer*.

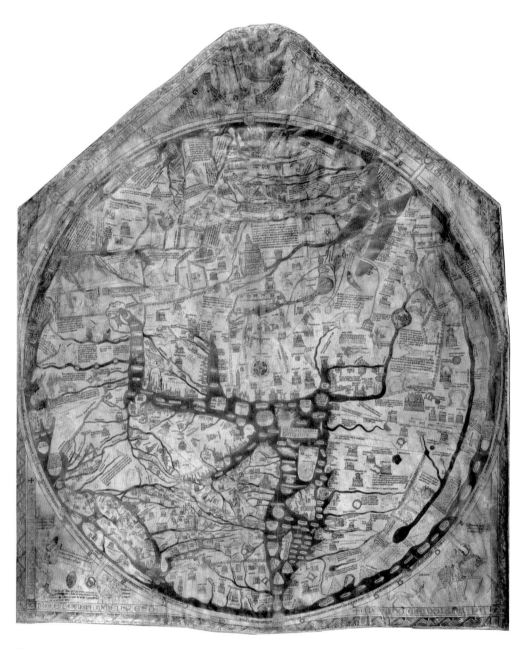

Richard de Bello, *Mappa Mundi*, c.1290
Pigments on vellum, 158 x 133 cm
Hereford Cathedral, Herefordshire

MAPPA MUNDI

The new VW Beetle is one of the most beautiful cars on the road. What makes it beautiful is the way it transforms the classic Beetle. We see the new model, not as an original design, but as a variation on a familiar theme. The earlier form is still visible in it, but everything is rounder, smoother, chubbier, bouncier. It's as if the old Beetle had been redrawn by Fernand Léger or Walt Disney.

This is what happens with a redesign. The new product is perceived as a re-shaping of the old. Or that's what happens at first. For after a while the new becomes the norm, and the old starts to look like the variant. Today, the classic Beetle is still on the road and its image is strong in our minds. In time the new car will become the standard, and the old one, when we bump into it, will look like a revised version – a skinnier, tinnier version – of *that*.

It's the same with old maps. We can never see them as themselves. We can't help viewing them as modern maps that have undergone a curious metamorphosis. We notice how the world has been pulled out of shape, how its edges have become more jagged or more blobby, how some unknown land has been added and some known land taken away. The pleasure of an old map, like a redesign, is largely in this sense of mutation, the tug felt between the ancient and the modern form.

With maps, unlike cars, there's also the issue of truth. Maps, we believe, are supposed to get the world right. So old maps are not just different, they are spectacularly inaccurate. That's the rational response at least. But it is hard to stop believing that a map tells some kind of truth. And old maps, by reshaping the atlas, don't just play variations on familiar forms. They offer images of alternative worlds, lost worlds.

Of course, for these effects to occur, there must be some common ground between old and new. We must be able to recognise our world, just, in the antique chart. The great *Mappa Mundi* in Hereford Cathedral lies on the very edge of recognition. It is the most complete medieval world map to have survived, and uniquely its maker is named – Richard de Bello, a priest from Lincolnshire. But it would be odd to call him a cartographer. The information on the Hereford *Mappa* is derived from all sorts of sources but from no original survey. Even

a glance reveals mapping practices that are deeply alien, beyond mere factual inaccuracy.

The known world, circa 1300, Eurasia and Africa, is shown as a single circular landmass, with sea all round, and the Mediterranean in the middle. East is at the top – turn the map ninety degrees clockwise to get it the normal way up. The city of Jerusalem is bang in the centre, the hub of the world. The red tooth shape, top right, is the Red Sea. And as well marking towns and waters, this map is packed with images and captions, illustrating the Bible, mythology, folklore, travellers' tales.

The Garden of Eden appears at the furthest point east. The isle of Crete has its labyrinth. Noah's Ark rests on a mountain in Turkey. Legendary beasts, monsters, savages and 'men whose heads do grow beneath their shoulders' are dotted all over. Christ in glory appears at the very top, and the band going round the edge is filled with gargoyles and allegories. It seems this is not a geographical world map at all – more a theological diagram of the world order, plus a gazetteer of medieval general knowledge.

And yet it could be even *less* geographical. The Hereford *Mappa* is a development of a more primitive model of *Mappa Mundi*, the so-called T-O map, and a great improvement on it. The T-O map shows the world as a perfect circle, an O, split up by a T of water into three entirely separate, geometrical, cake-slice continents: a semi-circular Asia above two quarter circular segments, Europe and Africa.

By comparison, the Hereford *Mappa* is a paragon of accuracy. It knows that coastlines are wiggly. It knows that Europe joins Asia. It knows that Italy and Greece stick out into the Mediterranean. It is weak on distances, but sound on general orientation: if you wanted to go from London to Paris or Jerusalem, it would point you in the right direction. It becomes pretty useless the further south or east you go, but around Europe and the Mediterranean it gets the topology of countries – what's next to what, or divided from what – mainly right, even though their shapes are wild. It is near enough to a modern map to register as a revised version of the same thing.

At which point, a sense of mutation and fantasy takes over. *Mappa Mundi* seems to show us a world that's like our world, but extremely altered. You can read it as a kind of geographical caricature. Look especially in the bottom left corner, where the British Isles are crammed tightly into a scoop of Europe. It's interesting that along with Hibernia and Anglia, Scotia is shown as a separate island. But the main thing you notice is what turd-like forms the Isles have become – still recognisable, but rudely distorted, as if redrawn by a derisive cartoonist.

Equally, you can see the *Mappa* as a form of fiction. We have historical fiction. Why not geographical fiction – or counterfactual geography, a sci-fi genre that imagines the planet with alternative geological outcomes? In fact, the way the *Mappa* rounds everything up is rather like maps showing the continents in their primordial state, before the continental drift, when the world's landmasses were like a bunch of kittens, waiting to uncurl.

The *Mappa* certainly makes the world feel a smaller, snugger, safer place. It makes it more like an organism, a self-regulating biological system, veined with connecting waterways, a single cell protozoon. It makes it resemble a diagram of female reproductive organs.

Granted, these responses are fanciful and anachronistic. They treat the *Mappa Mundi* as if its deviations from modern maps were deliberate, as if it were creative play upon the world as we know it. Perhaps this kind of free association simply sounds silly. Certainly, it isn't much talked about. But something like that is what goes on in our heads when we dwell on medieval maps. It's the main reason why we find them so fascinating. They don't just give a glimpse of an old mindset. They give our own minds a new world to travel in.

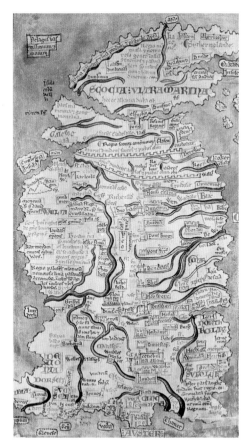
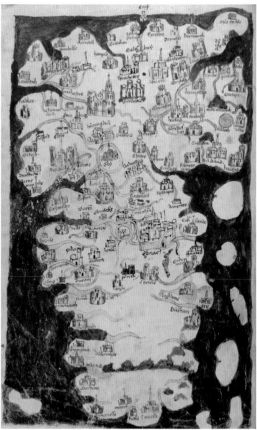

Matthew Paris, *Map of England, Scotland and Wales*, *c*.1250

Pigments on vellum, 32.2 x 21.4 cm

British Library, London;

Chronicle of England from the *Totius Britanniae Tabula Chorographica*, *c*.1400

Pigments on vellum, 24 x 17.5 cm

British Library, London

TWO ENGLISH MAPS

Very like an island . . .? All maps before a certain date are free. There are no uniform or standard plans. They are simply possibilities. True, some of them are trying to make documentary surveys. Some are fixed to myths and formulae. But they are limited. And beyond that, there is another realm of likeness. A piece of ground can't help become a shape. An island in particular is a piece of drawing. Its coastline makes a defining contour, which can naturally create beasts or things. Islands breed fantasies.

Take this pair of British islands. One is a map of Great Britain, about 1250, and drawn by Matthew Paris. He was a Benedictine monk, an artist in illuminated manuscripts, based in St Albans Abbey. The other island is also Great Britain. It comes from a *Chronicle of England*, at the coronation of Henri IV in 1399, made for a map of *Totius Britanniae Tabula Chorographica*. The cartographer is anonymous, drawn one hundred and fifty years later.

What connects these two maps? Both of them are to us recognisably British. Their likenesses may seem a little remote, but they have, clearly, the anatomies that we still know and name, and they share identities between themselves, and between many more modern maps. On the other hand, their different imageries are equally impressive.

Look at these two forms. In ancient or modern maps, it is normally possible to see Great Britain as a body with a head. But here there is a visible contrast. One of them shows the head up; the other one shows the head down. More than that, the Matthew Paris map suggests Scotland as a head with an open mouth. And seeing that, its whole body becomes like a creature. Its contour has jagged edges like vertebrae all round its coastline. It could be a primitive fish, a whale.

Meanwhile the coronation map is clearly upside down, and the head itself is much less conspicuous. In fact, it doesn't register as a body at all. This map has coastline with a soft outline – curvaceous, looping, billowy. There is no hint of creature now. It is a puffy cloud.

Or at least, you can see this, if you wish. This whale, this cloud, are only fictions, and fictions seen only by ourselves, not by their original makers, who would not even acknowledge these figures. But for us these acts of shaping can generate

inspirations. After all, we can look for images in thrown ink patterns. We can read pictures in nature's forms. Leonardo is famous for suggesting scenes in chance stains on walls. Blobs and silhouettes and bingo!

The only difference is that maps can appear both as designs and as accidental formations. They pull us towards and away, tempting us to geography and to association. Or perhaps we are bound to find likenesses. These two islands propose wild and opposing inventions. One swims in the sea. One floats in the sky.

Follow further lines of fiction. There are books that have images, which echo those likenesses. There is an island that is a whale. There is an island that floats. There is a cloud that is a whale. Milton's *Paradise Lost* shows a vision of Satan. His monstrous body is compared to the gigantic whale, so big that fishermen believe that it is a land . . .

> that sea-beast
> Leviathan, which God of all his works
> Created hugest that swim th' ocean-stream.
> Him, haply slumbering on the Norway foam,
> The pilot of some small night-foundered skiff,
> Deeming some island, oft, as seamen tell,
> With fixed anchor in his scaly rind,
> Moors by his side under the lee, while night
> Invests the sea, and wished morn delays.

An island is a whale. And Milton's comparison between Satan and whale is also inspired by medieval images. The whale's mouth is often pictured as the mouth of Hell.

Or take the political fantasy in Swift's *Gulliver's Travels*. The Kingdom of Laputa is 'The Floating or Flying Island'. Now, it is not itself a floating cloud. On the contrary, its description and its map show it as exactly circular. It hovers in the air through a magnetic lodestone: 'it is in the power of the monarch to raise the island about the region of the clouds and vapours . . .'. And it is principally a war

machine, designed to bring down power upon the subject cities beneath it. The Kingdom of Laputa, in fact, is an *anti* cloud-island. It rains down destruction.

Or you can see these two islands, one cloud, one whale – and what connects them is in *Hamlet*, in the teasing-maddening dialogue between Hamlet and Polonius.

> Hamlet: Do you see yonder cloud that's almost in shape of a camel?
> Polonius: By th' Mass, and 'tis like a camel, indeed.
> Hamlet: Methinks it is like a weasel.
> Polonius: It is backed like a weasel.
> Hamlet: Or like a whale.
> Polonius: Very like a whale.

These similarities can become a relay of echoes. Whale is island. Island is cloud. Cloud is whale. Of course there is no authority or genealogy in these parallels. There are no intended likenesses in this map or that map. There are no links betweens maps and these later books, or among these three books themselves. They come together entirely by luck. But these early maps are a treasure trove. Imagined coastlines become new lands, new worlds. Old Great Britains are discoveries. Very like an island . . .?

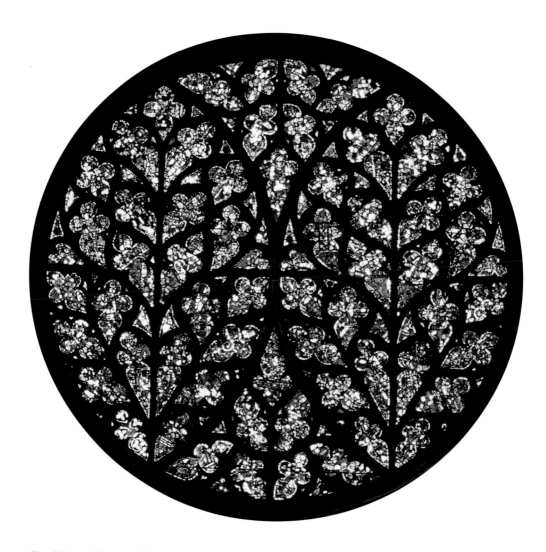

The Bishop's Eye, *c.*1320
Stained glass window
Lincoln Cathedral, Lincolnshire

THE BISHOP'S EYE

A rose is a rose is a rose.

But for anyone whose idea of a two-dimensional image is a relatively small rectangle hanging on a wall, the rose windows of the Gothic cathedrals present an unusual kind of picture.

They're enormous. They're seen from a great distance. They're seen at an angle, not face to face, but from below. And they're radiant, lit from the back, and often glowing out of near-darkness. Put these factors together and you have something that is, in fact, not so far from our experience. Nothing like a painting, it's quite like cinema, or an enormous video-screen.

Then differences begin again. These windows don't make the world huge as cinema does. Relative to the whole image, the pictures are miniature, and often hard to grasp. The idea of stained glass as the Bible of the illiterate, a giant visual aid, must often have been a hopeful exaggeration. It would have taken a sharp and educated eye to decipher the images.

But what makes rose windows most alien to the modern viewer is their structure. These images don't consist of a single integrated area. They are segmented, made of dozens or hundreds of demarcated shapes, the whole configuration divided up and held together by its framework of stone tracery and lead calms. Their parts are arranged in complex hierarchies displaying a mixture of strict order, free doodling elaboration and casual irregularity.

A rose window is not a field of uniform pixels. It's made up of units within units, forms within forms – descending from the big defining outer ring right down to the small and randomly-shaped chunks of coloured glass which are its fundamental atoms, with many levels and sub-levels, patterns and sub-patterns in between. The stained glass may be illustrated with pictures or with decorative elements. But as much as the imagery within them, it's the structure of these mighty diagrams that carries their meaning – and sometimes leaves us guessing.

Two great rose windows face one another across the north-south transept of Lincoln Cathedral. The north rose is known as *The Dean's Eye* and the south rose as *The Bishop's Eye*. They were first made in the early thirteenth century. In the

contemporary *Life of St Hugh of Lincoln* they are described as 'the two eyes of the church'.

As 'north represents the devil, and south the Holy Spirit, it is in these directions that the two eyes look. The bishop faces the south in order to invite in, and the dean the north in order to shun; the one takes care to be saved, the other takes care not to perish. With these Eyes the cathedral's face is on watch for the lights of Heaven and the darkness of Oblivion.'

That's one reading, anyway. But this interpretation may not fit with what can be seen today. The *Life of St Hugh* was written in around 1225. About a century later the south rose window, *The Bishop's Eye*, had to be reconstructed. And while *The Dean's Eye* has a concentric layout that could be considered ocular, *The Bishop's Eye* is now not so eye-like.

The Bishop's Eye is unlike the great majority of Gothic rose windows. It doesn't have a revolving structure. Rose windows perform countless variations on the revolve. Their parts are arranged like planets in orbit, spokes of a wheel, radiant beams, exfoliating petals, in cross formations, in star formations – but always the pattern is rotatable. It's focused on the centre point of the circle, and usually there is a central section at this point, the window's heart or hub. These windows picture an eternal, circling, radiating, God-centred universe. Not so *The Bishop's Eye*.

To put it geometrically. The circle of this window has been intersected by two arcs with the same diameter. The centres of these arcs lie on opposite sides of the window's circumference. The two arcs touch at the window's centre. They create a pair of upright almond forms. Each almond is then bisected vertically – almost all the way – by a straight line. Within these forms there's a network of tracery, its shapes mainly irregular long-tailed quatrefoils.

So the layout is essentially binary. Each almond is symmetrical around its vertical axis. The two almonds are symmetrical with each other. Indeed the whole rose (including the bits not within the almonds) is symmetrical around the vertical axis. So, although circular, this rose window does not hold a vision of centred order, nor a snugly interlocking yin-yang either. It presents a balanced division of

two separate equal parts, left and right. The old and the new testaments, perhaps? The saved and the damned?

But students of symbolism will already be hot on another trail. Because this almond form, the *vesica piscis* (fish's bladder) as it's known, has an extremely versatile symbolic repertoire. The 'measure of the fish' was considered a mysterious and sacred shape by Pythagoreans. Among pagans it could signify the vagina. Among early Christians, as the 'Jesus fish', it signified Christianity itself. And in Christian art, as the Mandorla, it was an aureole or cloud of divine glory.

Meanwhile, students of the bleeding obvious can see in *The Bishop's Eye* a couple of leaves. The reason why the window is non-rotatable is that fundamentally its structure is not cosmic but biological. It spreads, in the manner of vegetables, in a single direction: upwards. Within the almonds, the tracery ramifies like the veins of a leaf or the branches of a tree. The whole formation is cellular. You might even wonder if this binary window holds the secret of life itself – the basic reproductive dividing of cells.

Whichever reading takes your fancy, the imagery of the window won't help. It's lost. The stained glass was smashed out during the campaign against 'abusive images' in the English Revolution. The pieces survived. But when they were returned to the window, in the late eighteenth century, they were put back higgledy-piggledy. The restorers didn't try to jigsaw the original images together. They had regard only to effects of colour and radiance.

This is common practice in English stained glass restoration. If you can get up close, you see a prophet's head spliced against a horse's tail and an angel's wing and a shard of non-specific blue, and you try to make these fragments work as a consistent scene, and you can't do it. But this mixed-up language is somehow familiar. Yes, it's collage. It's Cubism. Out of one art of fragmentation, another is born.

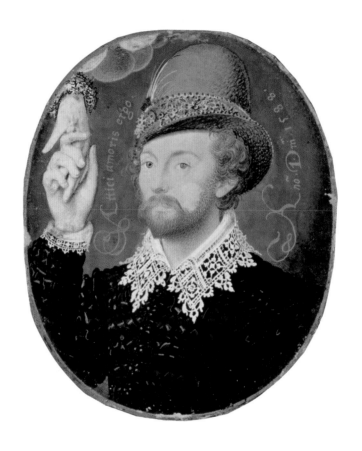

Nicholas Hilliard, *Portrait of an Unknown Man Clasping a Hand from a Cloud*, 1588
Watercolour on vellum, 6 x 4.95 cm
Victoria & Albert Museum, London

PORTRAIT OF AN UNKNOWN MAN CLASPING A HAND FROM A CLOUD

Images are mostly not for looking at. They are for being there and having around. Take family photos. A grandmother, say, sits in her sitting room, surrounded by framed pictures that are set up on tables, shelves and mantelpiece. They show the various members of her family, living and dead and newly born. They show children at different stages of their growing up. They show family occasions.

What's the point of these images? They aren't meant to be beautiful pictures, or psychological studies, or documentary dramas. They're not informing the old lady of what her family look like, or reminding her of their existence. She may not even turn her eyes upon them much. Their role is to stand for family members and family events, to make them present, to bring them near.

Family photos in a living room, or placed on an office desk, or carried in a purse, or used as a computer screensaver: these images are doing something that images have always done. The technology may be modern, but the function is immemorial. It's the same with the poster in the fan's bedroom, or the hate-figure stuck on the dartboard. The picture is an effigy that substitutes. It performs a kind of magic.

The effect is so everyday that we hardly notice it, and it would be strange to say that these images had supernatural power. Nevertheless what they do for us overrides the laws of nature. They make the absent present. They bring the distant together. They're a way of staying close, keeping in touch, holding on to your nearest and dearest when they're away.

It's more about bonding than looking. Though the image is a visual likeness of the person it proxies, the job it does is not essentially a visual one. It's a token that stands for somebody. It's a surrogate presence, which can create a mantelpiece family gathering or be carried on the person. It may be gazed at from time to time, but when it's not in view it's still playing its role.

Yet if the image in question is not a family snap, if it's an old portrait mini-ature, then it tends to lose that role. It ends up in a museum or gallery. The private proxy image is turned into an art object. It is very misleading. To find it on display gives the impression that the public domain is where it belongs. And to gaze on it through security glass suggests that its purpose is to be looked at, and only looked at. And to go to the next step, and see it in reproduction – that is probably even more misleading. On top of everything else, you lose a sense of its scale.

The miniature, as a matter of fact, is not named after its modest size. The word doesn't come from the Latin *minimus,* meaning very small. It comes from the Latin *minium*, meaning red lead. It referred originally to the red lead paint with which the capital letters of an illuminated manuscript were painted. But the name got transferred, partly because of the verbal mix-up, to the little pictures that were painted inside these letters, and then to any little picture. All the same, with the portrait miniature, size is crucial.

Nicholas Hilliard's *Portrait of an Unknown Man Clasping a Hand from a Cloud* is much smaller than you see it here. (Unlike most pictures, miniatures generally get enlarged in reproduction.) In reality its dimensions are six by five centimetres. This image, in other words, is like a pendant gem, or a lock of hair in a locket. It's an image to be hung round the neck rather than on the wall, worn close to the body, near to the heart.

It must be some kind of love token. Though the man is unidentified, and the inscription is obscure – *Attici amoris ergo* – it has love as its middle word, and it seems to be a lady's hand that descends from the cloud to hold the gentleman's. Getting both hands and the tuck of cloud into this little world is a squash. Most miniatures make do with a head and shoulders. But the presence of the hands, hand-in-hand, adds a special stress. It emphasises that a miniature image is not just small and portable. It's specifically hand-sized. Smaller than a mobile, it is something a hand can close on.

Hands give. Hands link. Hands plight their troths. Hands hold tight, hold on. Love is often done with hands, and portrait-miniatures, being hand-sized, are made for hands in love. Giving a miniature says: I give myself to you, I put

myself in your hands, hold on to me, keep me safe, don't let me go. The miniature encapsulates its subject, turns a person into something that can be wholly enclosed, wholly held, wholly handed over. It is a natural symbol of dedication, fidelity, intimacy, protection, connection across distance.

The way the woman's hand enters the oval from outside, to clasp the man's, only makes this connection explicit. It acts out the bond that any love-miniature stands for. It's as if her hand, by holding the image-token of the absent man, had managed to cross the distance between them, and reach him, wherever he is, and literally take his. While she grasps his miniature, his hand will always be in hers.

More than fidelity or intimacy, Hilliard's theme here is protection. The hand emerges from a cloud, and is therefore a helping or a guiding hand, a hand from Heaven. The woman left behind becomes like a guardian angel, watching over her travelling lover, and keeping him from trouble.

G. K. Chesterton said that 'to love anything is to see it at once under lowering clouds of danger'. The *Portrait of an Unknown Man Clasping a Hand from a Cloud* offers an antidote to that anxiety. While she holds on, a cloud of safety is always with him.

Nicholas Hilliard (1547–1619) did not always work small, but his miniatures are his fame. Trained as a jeweller, he mastered the tiny likeness, and his images have become icons of the Elizabethan court, preserving the faces of the Queen, Francis Drake, Philip Sidney and many unknowns. Miniatures were not only used as tokens of love or loyalty. They could have a kind of scrapbook function, as Hilliard said in his book *The Arte of Limning*, 'It is for the service of noble persons very meet, in small volumes, in private manner, for them to have the portraits and pictures of themselves, their peers, or any other foreign persons which are of interest to them.'

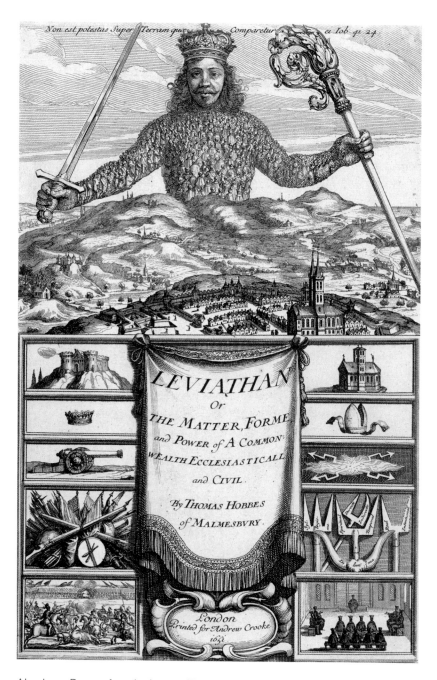

Abraham Bosse, frontispiece to Thomas Hobbes's *Leviathan*, 1651
Etching, 24.1 x 15.5 cm
British Museum, London

LEVIATHAN

English illustration is a strong tradition. There are many books that can hardly be imagined without their images. Edward Lear's nonsense rhymes come with his nonsense drawings and Beatrix Potter's tales are more than half-told by her watercolours. The world of Lewis Carroll's *Alice* books is partly the creation of John Tenniel's pictures – and ditto Charles Dickens's *Oliver Twist* and George Cruikshank's.

William Blake is the supreme joiner of text and image. Meanwhile there are many lesser graphic artists who have used their talents to visualise *Paradise Lost*, *The Pilgrim's Progress* and *Gulliver's Travels*. The tradition of English illustration has typically been devoted to the fantastic and visionary.

Yet one of the most fantastical and memorable examples of the tradition isn't connected to a work of imagination. It's found in a famous treatise of political philosophy – on the first page of Thomas Hobbes's *Leviathan: The Matter, Forme and Power of a Common Wealth Ecclesiasticall and Civil*. This illustration is an Anglo-French co-production: drawn by a French artist, Abraham Bosse, but designed in collaboration with the philosopher. It shows a giant that represents Hobbes's idea of the absolute state.

He bestrides the world like a colossus. The text along the top quotes the Latin Bible, from the Book of Job, and describes the monster Leviathan: 'There is no power on earth that can compare with him.' The giant wears a crown. He rises behind the horizon, and wields a sword and a crozier, emblems of civil and Church authority. But his most striking aspect is the way his torso and arms are made up of numerous densely crowded little figures. He is a swarm-man.

As Hobbes puts it, '. . . the multitude, so united in one person, is called a COMMONWEALTH; in Latin, CIVITAS. This is the generation of that great LEVIATHAN, or rather, to speak more reverently, of that mortal god to which we owe, under the immortal God, our peace and defence.'

The *Leviathan* giant embodies the answer to Hobbes's great fear – civil war. (He was writing after the English civil war, in exile in France.) The populace agree to surrender all their fractious individual powers. They are incorporated into an undivided, conflict-free body: the all-governing, all-embracing state.

This mass of people is gathered like a congregation. They face inwards, reverently, towards the head of the mortal god, who gazes out over them. The figures in the multitude are very similar, wearing the same respectable hats and cloaks. They are all male. In other words, they represent the seventeenth-century franchise – though within that, no class distinctions are registered. The people are equal in their submission.

An image of total subordination then? Like many meaningful images, its meaning can become ambiguous. Hobbes gives his giant a head and hands of its own, organs which are not composed of little people. The power of the state is not just a matter of uniting the many into one body. Hobbes wants to suggest that the state has its independent ruling power. As a Royalist, he's thinking of a monarchy.

And so a division can open up between the king-head and the people-body. A potential conflict arises. Perhaps the giant can compel and control the throngs he contains. Or perhaps, since they make up most of his anatomy, he can't act without their collective cooperation. The theory may say that the multitude have merged into a single organism. But the picture shows an intractable creature, whose head and hands are free, but whose physical action is bogged down in clustering crowds.

Seen like that, the *Leviathan* giant is not a symbol of a monolithic tyranny – but nor does its head-body division quite threaten the kind of civil war that Hobbes dreaded. Oddly enough, it makes a good image of a constitutional monarchy, government rule restrained by recalcitrant democratic process.

But this great archetypal image can be seen in numerous ways. See it as a big body packed with little bodies: maybe it was an inspiration for images of the Wicker Man. The first one appeared, published by the eccentric English antiquarian, Aylett Sammes, twenty-five years after *Leviathan*. Or see how the body arises behind the landscape, out of nowhere. It's the same as the way the giant emerges beyond the horizon in the painting *The Colossus*, once thought to be by Goya, now de-attributed. One way or another, fantasy is this picture's destiny.

Abraham Bosse (1602–76) was a French Huguenot artist. A follower of the great printmaker Jacques Callot, he produced a large output of etchings, skilful but functional, on all sorts of subjects. He developed the art of caricature. His most famous work remains his frontispiece to *Leviathan*.

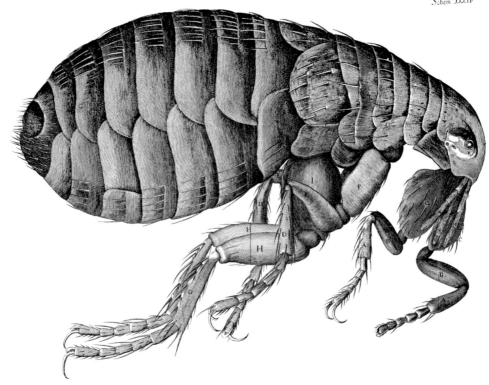

Robert Hooke, *The Flea*, from *Micrographia, or some Physiological
Descriptions of Minute Bodies made by Magnifying Glasses*, 1665
Engraving, 37 x 46 cm

THE FLEA

The traditional monster is a composite. The unknown is put together from pieces of the known. It is a work of imagination as defined by Thomas Hobbes: 'imagination being only of those things which have been formerly perceived by sense, either all at once, or by parts at several times', as when 'from the sight of a man at one time, and of a horse at another, we conceive in our mind a centaur.'

A centaur is a simple splice. Most monsters have more complicated recipes, a bit of this, a bit of that, batwing, horn, tusk, claw, fang, snake, fishtail, feather, scale, sometimes fused very finely. Think of the various dragons and demons that appear in pictures, such as by Bosch or Grünewald. But even the most monstrous, the most inventive, are collages of the normal. What makes them unnatural is their incongruous compound nature.

Words make this even clearer. At the climax of Racine's *Phèdre*, a vast and terrible creature rises from the sea-depths offstage, embodying all the destructive feelings of the drama. As described, it's a mix-up. 'The wave came near; it broke, and spewed up / Before our eyes, from the foam, a furious monster. / Its broad head was armed with threatening horns; / Its whole body was covered with yellowy scales; / An untameable bull, an impetuous dragon, / Its back was rippling into tortuous folds; / Its prolonged bellowings made the shore tremble . . .'. (C. H. Sisson's translation.)

But words can also disguise something that monster-pictures make all too clear: the fact that anatomical collages often make very implausible organisms. They can scare the living daylights out of us, but could these beasts live? Painters have put their imaginations into the shapes of their monsters, without imagining how they'd go. Even with the straightforward centaur, you may wonder whether a creature with two cardiac, respiratory and digestive systems could operate.

Monsters don't need to be imagined, though. The scientist and draughtsman Robert Hooke was a contemporary of Hobbes and Racine. He demonstrated how the extremes of nature can far exceed the extremes of the mind. All you need is a microscope. In *Micrographia, or some Physiological Descriptions of Minute Bodies made by Magnifying Glasses*, Hooke described and illustrated dozens of

minuscule phenomena, animal, vegetable, mineral, from the point of a needle to vinegar worms. The book has some marvellous images – the strands of silk, the barbs of a stinging nettle. The most spectacular is *The Flea*.

It is eighteen inches across. It folds out from the book. And the first reaction is shock at the sheer magnification. Imagine if a flea were that big! But other responses follow: curiosity, amazement. Magnification is a revelation: a new world. A creature normally known only as a speck that bites is made familiar in every detail. We can view its anatomy with the same intimacy, as with normal eyesight, we view some middle-sized animal. How complex this little body is. And gradually we forget the surprise of small-made-big, and treat the flea as an animal in its own right.

Hooke himself, having got to know his subject, is full of praise and affection for our blood-sucking enemy. 'The strength and beauty of this small creature, had it no other relation at all to man, would deserve a description.' He notes the flea's powerful jumping mechanism: 'These six leggs he clitches up altogether, and when he leaps, springs them all out, and thereby exerts his whole strength at once.' (Among his many other scientific projects, Hooke studied springs.)

And 'as for the beauty of it, the *Microscope* manifests it to be all over adorn'd with a curiously polish'd suit of *sable* Armour, neatly jointed, and beset with multitudes of sharp pinns, shap'd almost like Porcupine's Quills, or bright conical Steel-bodkins; the head is on either side beautify'd with a quick and round black eye, behind each of which also appears a small cavity, in which he seems to move to and fro a certain thin film beset with many small transparent hairs, which probably may be his ears; in the forepart of his head, between the two fore-leggs, he has two small long jointed feelers, or rather smellers . . .'.

This fierce creature, its body armed with plates and spikes, is as monstrous as anything in art. But the purpose of Hooke's words and picture is to incite not horror but a sense of strangeness-cum-friendship. See how this anatomy, though utterly different from any mammal, bird or reptile, is built on the basic animal model, with head, body, limbs. See how this mini-monster, for all its peculiarities, is perfectly viable. A flea is not a collage, a fiction, composed of bits. The picture

stresses how its separate parts go together. It is an integrated, articulate individual, a fellow organism.

We often take imagination as the great achievement of art. But the refraining from imagination can be just as great and often harder. What we see in *The Flea* is the discipline of observation. The wonder is that nothing has been made up (except if you will, by God): this extraordinary beast is nothing but the truth.

Robert Hooke (1635–1703) has been called 'England's Leonardo'. It's a bit of a stretch – no *Mona Lisa*, no *Last Supper* – but it recognises the variety of his talents. Hooke's draughtsmanship may have been self-taught, though there are stories that, when a child, he was apprenticed to Peter Lely, the Dutch portrait painter. As for science, he belonged to the great generation of British scientists, including Isaac Newton and Robert Boyle. He was curator of experiments of the Royal Society, and the range of his work is remarkable: microscopy, elasticity, gravitation. He worked with Wren rebuilding London after the Great Fire and originated the flat map. He coined the word 'cell' (after monks' cells) for the unit of living organisms.

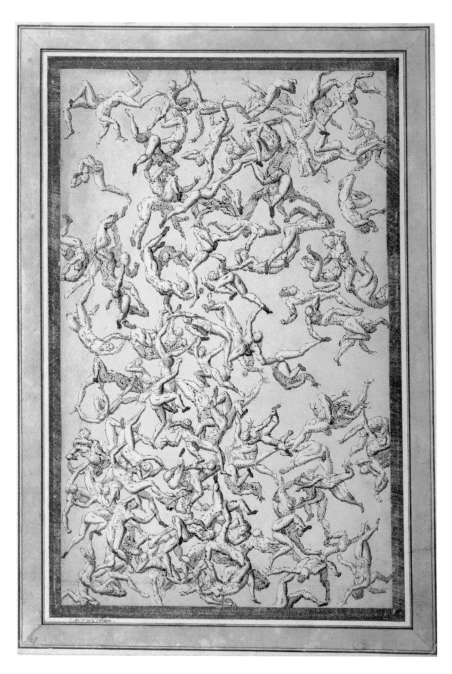

Thomas Carwitham, *Fantasy of Flight*, c.1713–33
Pen and ink and watercolour on paper, 37 x 23.8 cm
Tate, London

FANTASY OF FLIGHT

Absolute helplessness can be envisaged in opposite ways: as total bondage, paralysis; or as an entirely undirected, free-floating state. The first is probably easier to imagine, being nearer to normal experience. Everyone has got stuck somewhere. Few have been in a weightless chamber or lost in outer space. The second state lies more in the field of art.

Even in pictures, though, we may resist the idea of an absolutely unearthed space. We assume that imagination will conform, in its most basic ways, to our normal experience. We see pictures as oriented spaces, with an up and a down. Gravity falls through them, downwards. They have a visible ground at the bottom – or if not, an implied ground, somewhere off the bottom. The way we look at images helps this. A representational picture on a wall or a page clearly has a right way up; its up is our up.

Things need not be so sure. Pictures on ceilings or on floors are more uncertain. Their viewing offers us no clear orientation. They can be looked at equally from several angles. Or again, with some marked surfaces – pages of words, patterned wallpaper – though they have tops and bottoms, the force of gravity doesn't seem to apply to them at all.

There's an ink drawing by Thomas Carwitham that has acquired the name *Fantasy of Flight*. That certainty is surely misleading. On the contrary, at first sight you're likely to see it as an image of falling. You might associate it with pictures of the Fall of the Rebel Angels, where the devils are cast down wheeling from Heaven into Hell.

You get that falling impression mainly because this formation of twisting, naked, sexless figures is not evenly distributed around the page. It starts bunching up at the bottom, suggesting a pile-up, and offering evidence of ground and gravity and a general downwards trajectory. The lower edge of the image implies being lower down in space. It seems that Carwitham doesn't quite get the ways of the real world out of his head.

He almost does. His picture has no indications of locale, no concrete environment, on which a body could find a foothold or by which it could orientate itself. It is just figures on a blank, neutral background. You could turn it round,

look at it all four ways up, and it would more or less work whichever side goes at the top. As for flying or falling, there may be a slight collective sense of descent, but if you isolate individual or groups of figures, you find they're travelling on many different paths; with some it's not clear which way they're going in.

Their mode of propulsion is varied too. Nobody here flies, self-powered in air, like Superman. Some are tumbling, plunging. But some could also be swimming. Some could be blowing around – as the damned in Dante are driven like leaves on the wind. Some could be levitating and some are being flung. Some are rolled in mid-air, floating and flailing weightlessly.

This is outer space. The empty field of the paper is a limbo of helplessness. And taken en masse these figures are all over the place, lost in nowhere, like a scattering of marks dashed randomly around a page, like chits rolling in a tombola.

Thomas Carwitham: who was he? There are few more little-known figures in British art. He doesn't even have birth or death dates. His identifiable drawings and publications suggest he was active between roughly 1713 and 1733, a period (just before Hogarth emerged) that's one of the real low points in the history of British art. But he left one memorable work that could be a perfect image of oblivion.

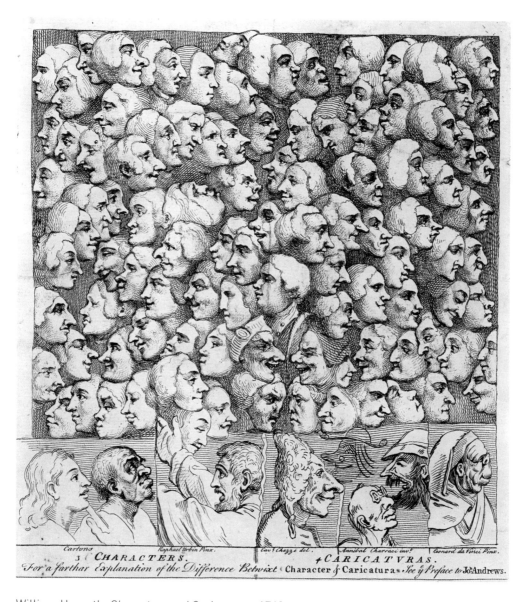

William Hogarth, *Characters and Caricaturas*, 1743
Etching, 25.8 x 20.4 cm
British Museum, London

George Stubbs (1724–1806) is the best English painter. Not Gainsborough, not Reynolds, not Constable, not Turner: Stubbs the horse-painter wins by several lengths. He began as a provincial in the north. He travelled to Italy. He spent two years on a full-scale visual analysis of the horse's anatomy. He went on to raise the semi-naïve, vernacular practice of animal painting to extra-ordinary heights. He makes horses a universal metaphor: they are highly bred, trained and socialised; or romantically wild, fighting with lions; or members of a serene utopian society. He treats all his fellow creatures equally. He is a master of design – of shape, rhythm, interval. He is a great colourist, a great comedian. He hasn't yet received his due.

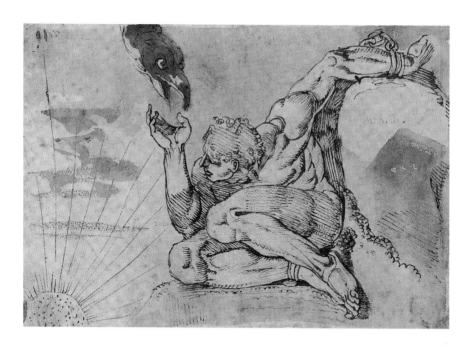

Henry Fuseli, *Prometheus*, 1770–71
Pen and ink and brown wash on paper, 15 x 22.2 cm
Kunstmuseum Basel, Kupferstichkabinett

FUSELI TO FRANKENSTEIN

Here are three games for making up bodies.

Game 1. *Exquisite Corpses.* This game was popular with the Surrealists, who gave it the name. It's also called Picture Consequences and it's a species of collage. Draw a head at the top of the page, fold the paper over so as to leave only the neck visible, pass it on to another person, who adds the torso, folds it over, passes to the next person, and so on. Each stage of the body is drawn by a different person. Then the paper is unfolded, to reveal the whole unplanned, mixed-up ensemble.

Game 2. *Blot.* This procedure was devised by the artist Alexander Cozens in the 1780s. On a page, with a full brush, rapidly and spontaneously dash down some pools of mid-tone ink. Let them dry. Treat each of these ink areas as the silhouette of a body. With darker ink, draw a body in a pose that will fit neatly within the shape. Cozens mainly used his blot technique to generate landscapes, but you could make human figures with it too.

Game 3. *Five-point.* This is a skilful and serious game, favoured by the Romantic painter Henry Fuseli. Fuseli and the sculptor Thomas Banks played it when they were in Rome in the 1770s. (Banks's daughter: 'He and Fuseli, when young fellow students in Rome, used to be very fond of comparing figures from five points placed at random . . .'.) It's a pictorial version of Twister. You rapidly and spontaneously dash down five marks on a page. You take these points as marking the positions of the head, hands and feet of a human figure. You must then invent a figure, in a pose, that will fit within these five positions. The purpose may be to produce weirdly bound and crucified figures. Or it may simply be to hone your anatomical virtuosity. At any rate, you have to be able to draw figures pretty accurately to play this game at all.

In Fuseli's *Prometheus* you can see where the guide marks have landed on the page, though it appears that two fell close together – or perhaps it was just a four-point game – because the feet overlap. The body is cramped, bent double, knees folded, head bowed, but with one arm painfully yanked up and stretched out behind. Fuseli has added chains and a rock to his drawing, to turn this trussed figure into a tormented hero, Prometheus Bound. It brings out what's implicit

in the method. The five pen-points are like bonds, or the nails of a crucifixion, pinioning the figure down or wracking it apart.

England at the turn of the eighteenth and nineteenth centuries was in cultural ferment. Fuseli was one of its starring artists and his amazingly prodigal, unstable imagination embraced pain, dreams, spooks, magic, heroism, sex, violence, terror, jokes, madness, perversity, satire, fairies, apocalypse. This was a visual culture that explored illustrations of Shakespeare and Dante, phantasmagoria slideshows, the cult of physiognomy, silhouette portraiture, personal and political caricature, an interest in Greek pots and medieval tombs, Michelangelo and electricity. It was the great age of English graphics. Fuseli apart, there are the visionary images of William Blake, the violent cartoons of James Gillray, the ultra-pure line drawings of John Flaxman, and the wild watercolours and set-piece sketches of George Romney. And the visual enterprise of the age was the free invention of the human body.

They were all at it. And whether or not they actually employed these drawing games, all three games are relevant to how the human figure appears. Bodies are contained and confined within a definite shape stencil. Bodies are pegged out upon an arbitrary geometric frame. Bodies are collaged together from separate pieces. This is against traditional academic canons, which required that anatomies should be sustained by a coherent skeleton, and that poses should be motivated by a sense of bodily action.

The body now becomes something at disposal. Its independent life is seriously compromised by this treatment. It's the opposite of life drawing. A body that's fitted to a given shape or frame is a body made from the imagination. And the freer the composition is, the less free the body that results. It is modelled against its own grain. It looks explicitly made-up, manipulated. You feel its moulding, positioning and assemblage as forces that act upon it.

It's a gym. In the work of Romney, who coined many of these contortions, or Flaxman, Fuseli, Blake, or even the amateur cartoonist Richard Newton, you can spot a recurring repertoire of these body forms. There's the diagonal, where the figure is ruled by a line slanting at forty-five degrees. The right leg, the

side of the torso, and the raised right arm are formed into a single straight slope. It doesn't look like a gesture. It looks like the body has been impaled, or struck by lightning. There's the vertical, where the figure is made into an upright bolt, legs straight, arms straight by the side, head straight up. Other forms include the C-bracket, where a bowed down body, usually grieving or brooding, is snugly contained within a firm C-shaped curve. And there's the ox-bow, where a cloaked figure, conjuring a spell, raises both arms above its head to make a horned or crescent form.

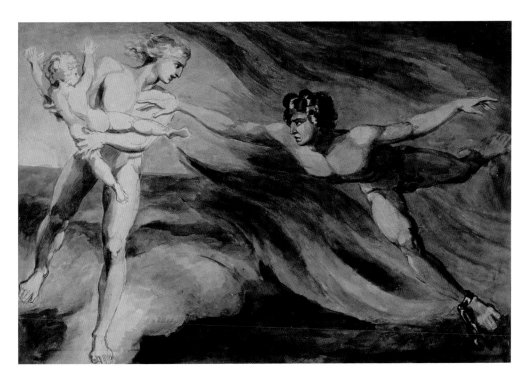

William Blake, *The Good and Evil Angels*, c.1790–94
Pen and watercolour on paper, 29.5 x 44.2 cm
Cecil Higgins Art Gallery, Bedford

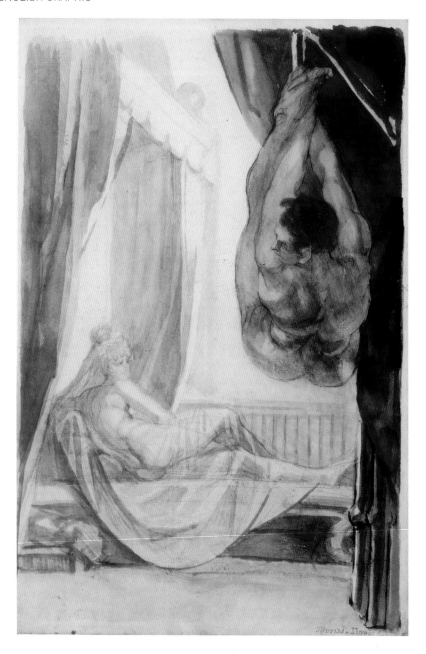

Henry Fuseli, *Brunhild Watching Gunther Suspended from the Ceiling on their Wedding Night*, 1807
Pencil, ink and wash on paper, 48.3 x 31.7 cm
Nottingham City Museums and Galleries

Sometimes the manipulations of the genre become outrageous. In Fuseli's *Brunhild Watching Gunther Suspended from the Ceiling on their Wedding Night*, the body of Gunther, strung up by the hands and heels, becomes a knobbly teardrop, a sack of potatoes. In Fuseli's *The Shepherd's Dream*, each of the big fairies, dancing in the air, is only a part-body, just a head and shoulders and outstretched arms – the rest disappears – made into a coat-hanger curve, and the curves are then joined up into a ring.

These shapes carry meanings. Fuseli was a friend of the physiognomist Lavater, familiar with the science of reading character into the body's configurations. Fuseli said: 'The forms of virtue are erect, the forms of pleasure undulate.'

It's not hard to see a likeness to modern body-building, with its cultivation and display of individual muscles, the deltoids, pecs and lats, and the way this super-development of parts makes the body look utterly helpless. No surprise, either, that Fuseli had a sideline in pornography, bodies put through their permutations.

Blake's practice is even more rigorous. All figures are fitted to a conspicuous template or diagram. The effect is iconic. Each body is fixed in its symbolic role, made synonymous with its shape and its meaning. It often becomes disembodied, a pictogram, a letter of the alphabet. And it's clear this highly inventive body art can go in two directions – either towards making the body into a pure sign, or towards making it weirdly palpable.

Indeed, whatever Fuseli said, erectness rarely signifies simple virtue. The figures impaled by stiff diagonals are hysterics, the victims of a spasmodic convulsion. The bolt upright figures are hovering apparitions or deranged automata. (Fuseli invented our idea of the robot, the zombie.) And all of his heroes are subject to a kind of puppetry or collaging, a matter of arms and legs and pieces of muscle, arranged. Piranesi remarked of his methods, 'Fuseli, this is not designing, but building a man!'

The built body? The most famous case of all was by a follower of Fuseli, Theodor von Holst. Look at the title page for the first illustrated edition of Mary Shelley's *Frankenstein* from 1831. It shows the creature as a slumped naked body, its limbs all over the place. It's clearly derived from a five-point composition.

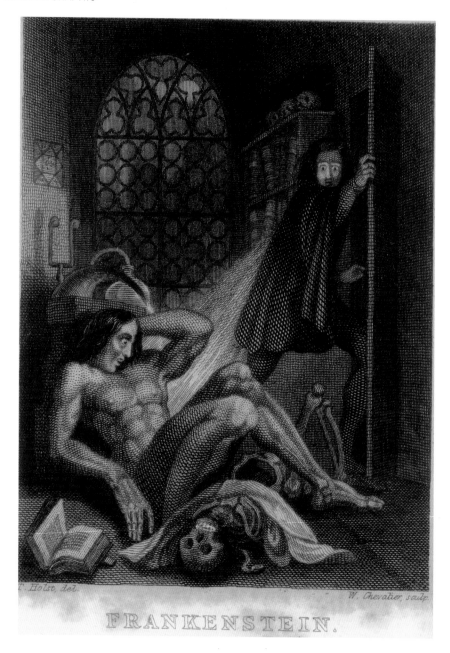

W. Chevalier after Theodor von Holst, frontispiece
to Mary Shelley's *Frankenstein*, 1831
Engraving, 9.3 x 7.1 cm

And how to bring the creature to life? It was Fuseli, looking at Michelangelo's *Creation of Adam* on the Sistine Chapel ceiling in 1808, who coined the great metaphor on the crucial minimal gap between the finger of Adam and the finger of God. He observed how 'the Creator, borne on a group of attendant spirits, moves on toward his last, best work . . . the immortal spark, issuing from his extended arm, electrifies the new-formed being, who tremblingly alive, half raised half reclined, hastens to meet his maker.'

Electricity was in the air. In the late eighteenth century it had become an important field of research and a fashionable form of entertainment. Luigi Galvani twitched – galvanised – frogs' legs with electric currents. Alessandro Volta invented the battery. Glasses of brandy were ignited by a spark from a man's finger. The King of France was amused by the spectacle of a mile-long line of monks being given a shock and simultaneously jumping in the air. There was speculation that the dead could be shocked back into life.

Electricity was on Mary Shelley's mind in the writing of *Frankenstein*. Though the force isn't mentioned by name in her book, she later explained that it had made the story seem possible: 'perhaps a corpse could be reanimated. Galvanism had given token of such things.' And what Fuseli sees in the *Creation of Adam* is some kind of Frankenstein scenario.

And as for the creature in the text, 'I collected bones from charnel-houses and disturbed, with profane fingers, the tremendous secrets of the human frame. In a solitary chamber, or rather cell, at the top of the house, and separated from all the other apartments by a gallery and staircase, I kept my workshop of filthy creation; my eyeballs were starting from their sockets in attending to the details of my employment. The dissecting room and the slaughter-house furnished many of my materials.'

How those 'fingers' and 'eyeballs' jump out at you! It's the most exquisite of corpses.

Alexander Cozens, *A Blot: Tigers*, c.1770–80
Watercolour on paper, 19.7 x 28 cm
Tate, London

A BLOT: TIGERS

There are various ways of randomly generating figures and one possibility is creative mess-making. In 1785, the English artist Alexander Cozens published a book called *A New Method of Assisting the Invention in Drawing Original Compositions of Landscape*. His new method, Cozens promised, would enable you to devise imaginary landscapes, never before seen in art or nature. The trick was what he called the 'blot' – which we might translate as splodge or scribble.

'To blot is to make varied spots and shapes with ink on paper, producing accidental forms without lines, from which ideas are presented to the mind.' With a full brush, you should rapidly and spontaneously dash down some patches and flecks of dark ink. You allow the random pattern of marks to suggest trees, hills, mountains, plains. Finally you work up the image into a finished, detailed view. Bingo: an original landscape.

Cozens was aware that Leonardo had recommended something similar, getting ideas for pictures by looking at the patterns of old, stained walls. But his new method was different. The artist makes the stain too, and the blot, unlike discoloured plaster, is not a totally random mess. It has an element of planning. The very first thing is to 'possess your mind strongly of a subject'. Form a landscape in your mind's eye. Then blot it down. Your quick blot will deliver a much more natural-looking scene than any careful drawing.

That's the virtue that Cozens explicitly claims for the blot. It's not about generating weird views as such. It's about making the imaginary look realistic. The blotted mess is inherently good at conjuring up the irregularities of landscape, much better than the premeditating hand. On the other hand, a blot doesn't seem such a good way of delivering a figure. Human and animal anatomies are too regular in form. Cozens himself made only one picture that isn't a landscape. *A Blot: Tigers* shows two beasts crouching against the sky. It's a strange image.

You can see how it evolved. In brown ink Cozens made a couple of almost featureless blobs. He treated these shapes as if they were the silhouettes of two animals. And within them, in darker ink, he filled in the detailed forms of the beasts. But did he have tigers in mind – or maybe some more abstract idea of

animal energy – when he quickly brushed up these blobs? Or were the tigers imposed on the blobs afterwards?

Well, there are some chancy shapes – whether found or made – that hold a strong if usually odd resemblance to a particular thing. You look at them, and you can see it. But other chancy shapes are just open to interpretation. They hold no undeniable likeness. They don't strongly resemble anything in particular. But if you try, they could be seen as a whole range of things.

Take the larger tiger. Imagine it back to the blot it originally was – with the darker detailing strokes removed, just a wobbly rounded pool of brown ink. What do you see in this inchoate form? The answer surely isn't: 'oh, yes, a crouching tiger!' But if the question is, 'what can you make of this form?' then there are several possibilities. It might be a boulder, a bush, a haystack, someone's head, a woman in a skirt, with a big bottom, bending over – or even, at a pinch, a crouching, snarling tiger.

The subject of *A Blot: Tigers* looks like it arrived after the event. This image doesn't suggest someone letting animal forms emerge through an act of half-random brushwork. It suggests someone looking at what they've done and having an ingenious idea. It's like the five-point game by other means. Here's a chancy silhouette. What animal, in what action, might it be the outline of?

On the title page of his *New Method*, Cozens puts an epigraph from Shakespeare. It's that beautiful speech in *Anthony and Cleopatra*. 'Sometimes we see a cloud that's dragonish, / A Vapour sometimes like a bear, or lion . . .'. But he could have cited the other, more famous and sceptical cloud-spotting passage in Shakespeare – from Hamlet's provoking dialogue with the ever-amenable Polonius: 'Do you see yonder cloud that's almost in the shape of a camel?' / 'By th'mass and 'tis, like a camel indeed.' / 'Methinks it is like a weasel.' / 'It is backed like a Weasel.' / 'Or like a whale.' / 'Very like a whale.'

That would be a truer motto for *A Blot: Tigers*. Yes, if you absolutely insist, very like a couple of tigers! And it's also the secret of the image's force and strangeness – the generative power of arbitrary metamorphosis, the way a shapeless mass can take shape as an animal, the feeling that anything can turn into anything.

Alexander 'Blot' Cozens (1717–86) was one of the most original forces in the English landscape tradition. While others were out searching Wales and the Lake District for picturesque scenes, he pursued landscapes of the mind. He saw pictures as first and foremost a matter of shapes on a page, visions of lights and darks, which could then be given more specific forms, though in many of his most beautiful works the image remains at the embryonic stage. He was a fashionable drawing teacher to gentry and royalty. Born in Russia, he was rumoured himself to be the child of Peter the Great.

George Romney, *A Foregathering of Witches*, c.1776–7
Watercolour and black ink wash over graphite on paper, 38.6 x 54 cm
Fitzwilliam Museum, Cambridge

A FOREGATHERING OF WITCHES

George Romney is an extraordinary figure. He's a divided artist, and he divides along the classic lines. There's a public face and a private soul, an outward conformist and an inner rebel. By day, top London portrait painter; by night, Romantic visionary draughtsman. These divisions are extreme. His work swings between the antipodes of late eighteenth-century English art, between Joshua Reynolds and William Blake. At the very least it's a highly improbable talent.

Romney died, insane, in 1802. I guess it's fair to call him forgotten. There are usually a couple of his firm, clear society portraits represented in any gathering of British painting, not attracting much attention. His free imaginative drawings have occasionally been shown, but they only ever get brief outings. His isn't the kind of art that can ever return in triumph. What his story offers is a 'what if?'

Romney began as a successful provincial portrait-painter in the north of England. He came to London hoping to paint grand narrative scenes, a standard high art ambition at that time. He became a successful metropolitan portrait painter. And for reasons of money and personality – Romney was a cautious, withdrawn, depressive character – he could never break from it. Indeed that was a standard predicament. It is not unhistorical to think that portraiture is boring. Blake thought so. Romney himself thought so. It's good. But it's boring. And Romney's drawings are often very bad, but they're not boring. Reynolds and Gainsborough also resented the face-painting racket they found themselves stuck in. If Romney's helplessness here seems more dramatic, it's because his other impulses are so way out.

He's a good portraitist. His speciality is the standing female figure, literally statuesque, with the pose derived from some classical sculpture, swathed in a dress that is almost a toga. He has a very strong sense of stance. He can put paint on vividly, creating a close identification between the pigment and what it represents, so that the flesh, hair or cloth seem to become tangible – not through looking solid, but by coming to the surface of the canvas, equating with the brushstroke,

George Romney, *A Foregathering of Witches (3)*, c.1776–7
Watercolour and black ink wash over graphite on paper, 38.5 x 54.8 cm
Fitzwilliam Museum, Cambridge

a materialisation effect that is magical and very satisfying. Chardin does it in his still lives, but I can't think of anyone else in England who does. It is a distinctive trick Romney has. He doesn't do it all the time, and it doesn't seem to have any particular meaning for him either. His portraiture isn't physically intimate. It's rather disengaged. It confers a lightly-worn grandeur on its sitters. There's a bit of psychological liveliness, a bit of charm and sensibility, but the human presence is low temperature, neither deeply penetrating nor enjoyably show-off. If this was all Romney's art was, it would only be respectable, as Romney himself knew very well.

What would Romney rather have been painting? Well, for example, Shakespeare, and Emma Hart (Lady Hamilton as would be), and water-babies. Romney's imagination was infused with Shakespearian drama, always at its most hysterical moments. His main attempt at a narrative painting is a vaguely

Michelangelesque shipwreck scene based on *The Tempest* (a bit of a shambles), and his sketches return frequently to the slightly absurd subject of *Nature Unveiling Herself to the Infant Shakespeare*. Then there are a series of 'fancy portraits' of the young Emma Hart, the recurrent object of Romney's artistic fascination. These are often uneasy images, with her head viewed from an awkward angle. Or, if you're seeking further evidence for Romney's 'weirdness', then there are the paintings of toddlers at sea, running into the waves, or perilously on board a small boat in rough weather. But the strange thing is, he paints these highly unusual subjects as if they were the most normal thing, with no special signs of intensity.

The drawings, though, are another world. Here the hand and the imagination flow together. But it is not just Romney's world. The turn of the eighteenth and nineteenth centuries was an amazing age of English graphic art. By graphic I mean non-painting – drawing, engraving, ink and brush. And I'm thinking of John Flaxman's pure outline figuration after Greek pots, Henry Fuseli's anatomical improvisations, Alexander Cozens's randomly generated 'blot' landscapes, William Blake's visionary illuminations, James Gillray's no less visionary caricaturing. Romney's drawings are in the middle of all this.

They go the whole range. In some ways they are ahead of the game. In a little image called *A Woman Holding a Bowl* the figure is done with a spontaneous brush outline that has been compared to Matisse. There's a drawing of a moonlit sky that seems to arrive by chance out of dabs and blots and spills. There are doodle figures, and extremely lunatic cross-hatched grotesque heads, which nowadays we'd term Outsider Art. (A lot of Romney's work is still in bound sketchbooks that, frustratingly, can only be exhibited open at one page.) Even where a drawing is clearly a study for a formal portrait, the distance between them is immense, because the drawing is about strokes of ink and shards of white paper as much as about figures and drapery.

What's original here is how the act of drawing comes first. The movement of the hand, the dense scribble of pencil lines, the dashing in of wash, these are the motive forces in these works. The imagery evolves organically from

George Romney, *A Foregathering of Witches* (4), *c.*1776–7
Watercolour and black ink wash over graphite on paper, 40.4 x 54.8 cm
Fitzwilliam Museum, Cambridge

the working, turbulent convulsions of figures and clouds. To say that Romney doesn't know what he's going to draw would probably be an exaggeration. He knows the subject, but he doesn't know how he's going to get there. And when he gets there the image isn't distinct from the energies and excitations of the medium.

It goes further than that. The sketchbook is integral to this side of Romney's work. His drawings evolve in page-to-page sequences. They're not moving towards some solution. Transition is their natural state. There's an extraordinary series of wash drawings representing (just) the witches scene from *Macbeth* in a wild and rocky scene, with spooky trees and a cloud of sacrificial smoke rising. To see one of them is never enough. The movement between drawings is part of the effect. They are a semi-abstract storyboard.

It's not surprising that Romney never managed to realise his imaginings as paintings. To do so he would have had to reconceptualise the art of painting. His sketches propose a very free relationship between paint and figuration, and – even more radically – an end to the one-off picture in favour of the kind of sequential composition that you find in late Picasso. (On which note, you might expect Romney's imagination to be more pornographic than it is.)

The nearest he came to this realisation is in a series of cartoons, full sketches for paintings, made in the late 1770s. They live in Liverpool, and can only be seen at the Walker Art Gallery. They're mythical fantasias – in one way very original, and in another, very disappointing. Romney has clearly cleaned up his act. He turns his organic sketches into constructed scenes with a very reduced tonal range, with all the dynamism taken out, and with figures whose outlines are limp and whose expressions are insipid. But again and again, in their strange anatomical coinages, the body converted into a symbolic unit, they prefigure Blake's work of the next decade. Blake very likely saw them.

Romney – a forgotten genius? Some like to claim it, and in terms of originality, why not? His techniques and ideas are sometimes very new. They promise plenty. But promise is their gift. Romney's experiments always look experimental. His free draughtsmanship hardly ever approaches the certainty-in-freedom of Rembrandt or Goya. His prefigurings of Blake are only striking because of what Blake did with them. He inspired Blake, but lacked Blake's inspiration. He deserves to be remembered, to be sure, and a few of his drawings should have a classic status.

George Romney (1734–1802) was, at the height of his fame, more fashionable than Reynolds and Gainsborough. Society portraiture kept him afloat but his drawings make another, stranger, story. An uneasy man, he went against the grain, refusing ever to become a member of the Royal Academy. He was born in Lancashire and made his career in London although he kept a family in Kendal and returned there to die. Romney's Kendal Mint Cake is named after him.

Francis Towne, *Ambleside*, 1786
Watercolour with pen and ink on paper, 23.5 x 15.6 cm
Yale Centre for British Art, Paul Mellon Collection

AMBLESIDE

Taking a line for a walk, that was Paul Klee's line. At the start of his *Pedagogical Sketchbook* he proposed 'an active line on a walk, moving freely, without goal. A walk for a walk's sake. The mobility agent is a dot, shifting its position forward.'

It's a lesson in how to draw without limits. Take up your pen, and wander. Make an unpredictable, meandering path across the paper. Be guided neither by the shapes of the world nor the rules of geometry. Simply go ahead, on any course, by impulse alone.

And it's possible. You can proceed like that. But the famous metaphor, though it sounds inviting, is also misleading. Going for a real walk, even a walk for a walk's sake, is normally less free than Klee suggests.

A pen can happily amble all over a sheet of paper, because a sheet of paper is smooth and flat. But the earth is not flat. The surface of the world upon which we normally take our walks is a distinctly uneven terrain. It is not a piece of paper. It has hills and water and vegetation and human constructs, all kinds of blockage. It has established paths, too – and lines of least resistance, which may (with use) turn into paths. These are the conditions in which we do our walking. Even when we don't have any plans for where we're going, even in the most open country, the lie of the land steers our footsteps.

And taking a line for a walk, if it were really like walking, wouldn't be an act of pure freedom, 'a dot, shifting its position forward'. It would have to negotiate obstacles. It would follow known roads. Klee's metaphor forgets the real activity that's behind it.

All the same, it reflects the reality of its time. The *Pedagogical Sketchbook* was put together in the early 1920s, when Klee was teaching at the Bauhaus, the now legendary German art school. This coincided with an active social movement, which had originated in the late nineteenth century, but became more organised after the First World War: the cult of hiking and country walking.

In Britain there was the Ramblers' Association getting underway. In Germany there were the *Wandervögel*, the Wandering Birds. These movements stood for liberty, for going where you wanted. Students of the Bauhaus were themselves

members of the *Wandervögel*. Klee's equation of drawing and walking, the linking of the free hand with the free foot, would have had a resonance.

But the history of art and walking goes further back, to the heroic foot-sloggers of the Romantic age. Remember the lonely traveller of Franz Schubert's song-cycle, *Winterreise*. Remember Caspar David Friedrich's painting of a great solitary, *The Wanderer Above the Sea of Fog*, standing on a rocky peak, turned away and facing mystically into the void.

Or remember Samuel Taylor Coleridge and his sublime fell-walking expeditions in the Lake District. 'The clouds came on – & yet I long to ascend Bowfell – I pass along Scafell Precipices, & came to one place where I thought I could ascend, & get upon the low ridge that runs between Scafell and Bowfell, and look down into the wild, *savage, savage* Head of Eskdale / Good heavens! What a drop . . .'. Physical and spiritual join in exertion.

Fifteen years before Coleridge went to the Lake District, the draughtsman Francis Towne had made his own trip. It was already established as art country, famous for its wild and dramatic character. ('Picturesque' was the word.) Towne's walking-drawing tour took him round Windermere, Ambleside, Coniston, Rydall Hall, Grasmere, Vale of St John, Keswick, Buttermere, taking in mountains, valleys, lakes and waterfalls.

Ambleside pictures its view from a high point above the town, perhaps from the church tower. It shows an upright scene, with the edge of the town, a stretch of flat fields in the valley beneath, then the sudden heights with their climbing woods, and the crests rising beyond. It's sunrise. The hillside is gloriously revealed by a light that comes from over the peaks behind us.

A vision: but everything is made out in clear outlines and clear areas. This is how Towne sees nature. He's not interested in moulding three-dimensional forms or in conjuring up vague atmospheres. He defines entities with ink contours. He fills their boundaries with flat hues and tones.

This is Towne's method when he's depicting the stable features of a landscape. But look at the 'tide-mark' of light and shadow that falls halfway up the hillside. Or look at the glimpse where, high up left, cloud and sky meet. Their borders

are equally abrupt, but their edges are not demarcated with ink outlines. There's only a division of tone or hue. It registers that they are insubstantial and transient natural phenomena.

There are fixed woods, hills, trees, rocks, houses – and then there are clouds, and cast shadows, and (in other pictures) reflections seen in water. The tide-mark of the shadow will swiftly sink. The clouds will blow across. They are signs of the changing times of day, the edges of the present moment.

But there are other linear effects in Towne's work, where marks are drawn in ink and lines could follow the routes of walks. Sometimes it seems they literally do. Look closely at the small white dwelling on the hillside, almost at the centre of the picture. See the line going up from it, on a leftwards diagonal. It follows a wiggling way. It surely traces a walking zig-zag path.

Even where Towne's lines probably don't literally take the lines of walks, they are walking lines. They are not free doodles, because walking isn't free, least of all the kinds of walking needed to scale and scramble up this rough and vertiginous terrain. Trace Towne's contours as they go up the edges of these steeps. They take the difficult and uncertain paths that walkers like Coleridge would take, as they mounted the grassy crags or crossed their ridges.

There are no lines in nature, it's sometimes said. But of course there are many. Many of those are the lines of paths. And Towne knew something Klee didn't: how a walking line goes.

Francis Towne, *The Source of the Arveiron*, 1781
Watercolour with pen and ink on paper, 31 x 21.2 cm
Tate Gallery, London

THE SOURCE OF THE ARVEIRON

Time travel sounds like an outlandish business, but really we're doing it all the time, whenever we look back at the past, and wonder what kind of dialogue there could be between them then, and us now. The question arises acutely with the arts – or at least, with the arts as practised in our culture.

For us, the arts are not just a present day activity. They're a tradition, encompassing a long time-span and large historical changes. The rules of our game say that what we do today, and what people did a hundred and five hundred years ago – it's all ours now. The arts of remote periods, though evidently very different, are to be viewed together, often in the same book or building.

That's how we do art, and it leads to a problem we're all familiar with. Our experience of it is beset by uncertainty. The art of the past sometimes speaks to us so clearly and directly, but sometimes we don't get it at all, and often we're not sure whether we do or not. We're continually aware of language barriers and the possibilities of misunderstanding. And we may suspect that when the past seems most familiar to us, that's when we've made the biggest mistake.

With art, we're all nervous or reckless time-travellers. We can try to avoid anachronism, but since we can never shed our contemporary selves, anachronism is the air we breathe. We always view ancient art (to some extent) through modern eyes. Just occasionally we catch ourselves in the act. We meet a piece of old art that reminds us so surprisingly of some more recent art that we have to say something. We say things like: 'seems almost to anticipate . . .'. We reach for the prefix 'proto'. The bizarre fantasias of Hieronymus Bosch seem almost to anticipate Surrealism. The extreme bodily distortions and wild paintwork of El Greco are proto-Expressionist.

We can't help seeing the more distant in terms of the more familiar. At the same time, we're conscious that this familiarity is probably deceptive. Our sense of affinity is some kind of anachronism. Bosch and El Greco didn't literally see into the future, Nostradamus-wise, to the art styles of the twentieth century. And they didn't, back then, see their own work in twentieth-century terms, as a Surreal pursuit of the irrational, an Expressionist cry of angst.

Besides, it's not as if their paintings would ever actually be mistaken for modern

ones. The likeness we can see is a strange likeness. What's fascinating about these affinities is precisely that they're remote, tenuous, conflicted, somewhat baffling.

Take this late eighteenth-century English watercolour by Francis Towne. Abstract? The word is inevitable. To our eyes, the overriding sense of pattern jumps out. The image is divided into distinct and outlined areas of flattish colour. It's a formation of enclosing shapes that twist and fold around and into one another. They're the sorts of shapes that, in the language of twentieth-century art criticism, were called 'organic': they don't represent anything specific, but they have the general profile of biological or geological phenomena. Graham Sutherland's work, for instance, is full of organic forms.

But of course this is not an abstract. *The Source of the Arveiron* is a view. Its organic forms represent actual geological phenomena. It shows a very spectacular Alpine scene: the immense Glacier des Bois, from which the River Arveiron rises, and the even immenser mountain-shoulders that rise above it. It is not even semi-abstract. There are no pure, unmotivated forms. Everything depicts something. Each of the picture's shapes stands for a wall of rock, a field of ice, a wooded height, a far blue peak.

So our response is divided. Our modern eyes, informed by the experience of abstract art, can't resist seeing a piece of pure abstraction. Yet we're well aware that it's not. We know that 'organic form' is not a term in Towne's artistic vocabulary. To see his work that way is to see it against the grain.

You can try to explain how this case of mistaken identity arises. It comes partly from how Towne observes nature. He's not so interested in solid form. He downplays the way appearances modulate and blur and blend. His stress is on the different kinds of stuffs there are in the world. His approach to landscape is rather like a child's painting, where grass is green, wood brown, leaves green, sky blue, clouds white.

It's a picture that tells you about what the world's made up of. Each type of thing – glacier, rock, wood, mountain – is demarcated, made into an outlined shape and given an almost uniform colour-label that distinguishes it from the other things/shapes. It is painting by names. It's a kind of map-making.

Towne does thing-mapping in many pictures, but in *The Source of the Arveiron* it goes further. If you're going to turn the visible world into a patchwork of flat shapes, it means that the edges of these shapes, their silhouettes, must carry most of the information. This scene becomes abstract because its mountainous forms are so large and inarticulate. Their vaguely bumpy or curvy profiles are without telling detail. They carry the minimum of information. So it's very easy to see them as just a pattern of pure shapes.

And surely, the thought returns, *surely* Towne must have had something like that in mind. Our perception of abstraction can't be entirely mistaken. He must – in the course of painting this landscape – have had an inkling of another kind of painting, and taken at least the first step towards it. Or subconsciously anyway. Or something.

Yes, say that if you like. It's an occupational hazard of having an artistic tradition. Indeed it's practically the point. Across the centuries, even if at cross-purposes, it's good to talk.

Francis Towne (1739–1816) was one of the most brilliant and original of the English landscape watercolourists. In his time he was an inconspicuous figure. Devon-born, a provincial drawing teacher by profession, he travelled around sublime and picturesque sights – Roman ruins, Alpine peaks and torrents, Welsh hills, Lake District lakes – and rendered them in firmly outlined shapes, in areas of pure and contrasting colours. The technique makes nature, even when it is vast or violent, feel serene and luminous. The world is analysed into its separate parts. Every element is contained and identified. Towne exhibited in his day, but fell from view. He was only rediscovered in the early twentieth century. Like other Romantics he was cast then as a precursor of English Modernism. Later eyes have found his art packed with pre-echoes: Cézanne, Japanese prints, abstraction.

Thomas Clarkson and the Committee for the Abolition of the
Slave Trade, *Stowage of the British Slave Ship 'Brookes' under the
Regulated Slave Trade Act of 1788*, 1789

THE BRITISH SLAVE SHIP 'BROOKES'

The power of art has received many tributes, often from those within the profession. But if you're interested in images that have real power in the world, they're probably not going to be bona fide works of art. They're going to be cartoons, posters, documentary photos, emblems, logos, maps and plans. Perhaps the most politically influential picture ever made is not a painting but a diagram; and it was devised not by an artist but by a campaign group. Its full title is *Stowage of the British Slave Ship 'Brookes' under the Regulated Slave Trade Act of 1788.*

It was produced by Thomas Clarkson and his allies in the Committee for the Abolition of the Slave Trade. It is a landmark in the understanding of visual propaganda. It manages to communicate, at a glance, an incontestable evil. It could carry its message into the minds of those who weren't willing or able to read the Committee's carefully mustered petitions and witness statements.

It undermined all claims about the pleasant and commodious conditions enjoyed by those taken on the 'middle passage' from Africa to the Americas. ('One of the happiest periods of a Negro's life,' said a spokesman for the slave lobby.) Its immediate focus was the supposed improvements introduced by Sir William Dolben's 1788 Regulating Act. It's still used in almost every account of slavery and its abolition. Its impact was and is immediate. Once seen, it's never forgotten.

The diagram wasn't, strictly speaking, a documentary record of the facts. It was a hypothetical projection. The Plymouth branch of the Committee had discovered a plan of a loaded slave ship. In London, Clarkson and his colleagues applied its visual scheme to a ship that was in the news. A Privy Council enquiry into the trade had measured the internal dimensions of a number of vessels and published the results. The Committee chose a Liverpool slaver, the *Brookes*, as an example: it was the first one on the Committee's alphabetical list.

The picture they developed is a statistical visualisation. It demonstrates how the ship's legally permitted number of captives, four hundred and fifty-four, might be accommodated within the available space of its various decks and platforms.

The section illustrated here shows the main level of the lower deck. In fact the *Brookes* was known to have carried six hundred and nine captives on a previous voyage. But the diagram stuck to the letter of the law.

'This print seemed to make an instantaneous impression of horror upon all who saw it,' Clarkson wrote. It became one of the first political posters. In April 1789 it was published in an initial run of seven hundred and widely circulated. Other editions and other versions followed. It was hung as an emblem in every abolitionist home. A clergyman compared it to Dante's *Inferno*. How does it make its powerful impression?

Abolitionist propaganda often used graphic depictions of human torment. The *Slave Ship 'Brookes'* conspicuously avoids that. It is an image of intolerable affliction, but it shows no bodies in visible pain. Its stiff little figures are individually far from expressive pathos. They're near enough token representations, in themselves no more likely to inspire sympathy than the symbols on a public toilet.

The force of the print is partly in its very understatement, in the sheer distance between image and reality. There is the neutral, demonstrational layout of bodies in spaces that we see. And there is the human experience, of imprisonment, pain, heat, stench, thirst and asphyxiation that is implied. The image requires the imagination to work, to think what life is like when people are stored in this way.

But also, this form of depiction seems to embody the mindset of the slave-trader. The diagram is itself dehumanising. It treats humans as commodities – 'live cargo' as the phrase was. In it, people have become items to be counted off, quantities to be fitted as economically as possible into an area, like fish or vegetables or books. Who can fail to notice the ingenuity, the neat patterning, by which (especially at the prow end) every last wedge of the ship's space is used? The slavers called it 'tight-packing'.

And probably the most horrific aspect of the *Slave Ship 'Brookes'* diagram is that, in one sense, it is an entirely adequate representation of its subject. It is a two-dimensional image that depicts what is in effect a two-dimensional reality. The captives are confined to the flat. While stowed below decks, their bodies are

restricted to a single plane, lying chained on the floor with very little headroom above.

What's more, there is the sense of overall squeeze. That's the other, two-dimensional fact that the image displays so explicitly: the clearly demarcated outline of the ship, the pressure of this confining boundary, the way the bodies, crammed together, are locked in by this limit. In abstract visual terms, the diagram shows a large number of distinct units, concentrated at maximum density, and held inside a simple containing shape. Translated into human terms: a nightmare.

The *Slave Ship 'Brookes'* resembles a mass grave. It would have tapped into strong contemporary fears – aroused by *The Monk* and other eighteenth-century Gothic fiction – about confinement and being buried alive. No representational picture could have conveyed that terror with the visual power of this cross-section diagram.

Visual power? And what about morality, and intellectual argument? Samuel Johnson, himself a notable opponent of slavery, remarked in another context that 'the rights of nations and of kings sink into questions of grammar, if grammarians discuss them.' And reading the above, you might equally feel that, when art criticism is on the case, the abolition of the slave trade is reduced to a matter of pictorial effects.

But sometimes visual power is what is needed. Bypassing all rational resistance, and all failure of imagination, the diagram addresses its lesson straight to the eye. Anyone can see what's going on. As another early viewer remarked: 'there is a greater portion of human misery condensed within a smaller space than has ever yet been found in any other place on the face of this globe.'

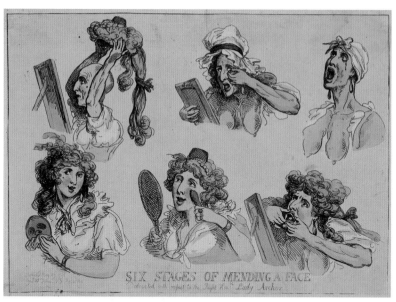

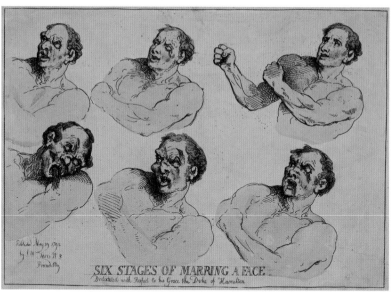

Thomas Rowlandson, *Six Stages of Mending a Face*, 1792
Hand-coloured etching on paper, 28 x 38 cm
British Museum, London;
Thomas Rowlandson, *Six Stages of Marring a Face*, 1792
Hand-coloured etching on paper, 27.4 x 37.6 cm
British Museum, London

MENDING A FACE /
MARRING A FACE

Insults. Let's think about the ways that a drawing can insult a person. Specifically the ways a drawing can insult somebody through their face. Never mind in drawing, in life there are two main kinds of facial insult. The first one is: you do a mocking impersonation of someone's face. You catch something about their look or expression and exaggerate it to make it look evil or stupid or mad.

The second one is: you physically have a go at the face in question – not punch it – but mess it up so that it doesn't work as a face. You might throw paint at it, or a custard pie. This has various effects; you've invaded the person's space in an intimate way, you've shown contempt, you've soiled them, done them proxy violence. But also, if you hit your target with paint or pie you've made their face dysfunctional as their means of expression. You've attacked their face as their image. If you transfer these two kinds of insult to the activity of drawing, then the mocking impersonation would be equivalent to caricature, and the paint attack would be like vandalising their image with iconoclastic graffiti.

These two approaches are very different in spirit, and usually in result. Caricature is a form of character assassination by means of a slanted likeness. Destructive graffiti is an attack on an already existing image, not by careful drawing but by scribbling, scratching, gouging, blacking-in and crossing out. And though these two drawing practices are far apart, the distance between them can be crossed. Destructive graffiti can insinuate itself into a depiction and produce deeply insulting images.

There is a pair of cartoon strips drawn by the English cartoonist Thomas Rowlandson in 1792 about the alteration of faces. They're called *Six Stages of Mending a Face* and *Six Stages of Marring a Face*. They each have the same structure. One of them, *Mending a Face*, goes from bad to good, and shows a woman, probably a prostitute, putting herself together in the morning, stage by stage – glass eye, wig, teeth, make-up – she's ready to go.

The other, *Marring a Face*, goes from good to bad, and shows a man, a boxer, with his face getting increasingly smashed up. The cartoons are a female and male

pairing. They play on, and against, traditional female and male stereotypes; Venus and Mars; woman devoted to love and beauty, man to warfare and heroism. Both sequences have an interest in incremental transformations, the pleasure of noticing small changes and measuring those gradual changes against the decisive overall arc.

The female sequence, *Mending a Face*, has an old and very standard anti-woman satirical idea. It says that women are false; they put on a seductive mask to conceal an ugly, rotten reality. There are many pictures and poems on this subject. And the sequence can go in both directions, the woman putting herself together (a mistress of disguise) or taking herself apart (the hideous truth). Rowlandson's strip doesn't add much to the traditional theme.

Marring a Face, on the other hand has more novelty value. Boxing had become a popular spectator sport at this time among the upper classes. This is bare-knuckle boxing of course, before the sport was regulated under the Queensberry Rules. Bare-knuckle fighting caused less brain damage than modern boxing but more spectacular, bloody facial damage. It is more visibly violent. The development of that violence is what Rowlandson shows – from first bruise to knock-out blow – and there's an additional level of wit in the way the course of the fight is shown only by means of the wounds inflicted. The man seems to be recoiling from the blows of an assailant who exists only by implication.

That's the plain subject. But Rowlandson is a very art-conscious artist, and you might guess that these pictures about the alteration of faces imply some analogy with the processes of art. *Mending a Face* easily suggests this. Making-up after all involves a kind of painting, a kind of idealisation that is comparable to what a portraitist might do to a face. And if you look at the last frame in *Mending a Face*, you see a face – the result of these strenuous cosmetics – that is actually very like the usual idealised face that Rowlandson does when he wants to do a nice young lady. A face you aren't at all supposed to think of as covering up a bald and raddled reality but to see as natural and charming. It's an odd little ironic moment.

But as for *Marring a Face*, with its cuts and bruises, its battered misshaping – what kind of artistic procedure is that like? Like caricature perhaps? Like the caricatures of Gillray for example, working at exactly the same time.

There's an element of caricature in this image. Of course the Rowlandson boxer is being mocked in his affliction. There are overlaps. But a battered head and a caricatured head are different creatures and they are different for several reasons. First, simply, a caricature couldn't be mistaken for a drawing of a wounded face, or a deformed face, or in fact any kind of actual face. A caricature makes it clear that it is a deliberate, artistic reshaping, not a depiction of a face that is itself strangely shaped. It's not true in every case and Gillray himself sometimes operates on the borderline; but the difference is usually clear, and if not visually clear, then at least important to recognise.

Second, caricature is an inside job. It is not an external assault like a stream of visual abuse or a handful of mud thrown at the victim's face. No, it is a kind of likeness. Its strange shapings aim to mockingly emphasise a character that is already there. Its insults aren't stuck on. In caricature the face is made to give itself away.

And third, the battered face is not like caricature because the business of caricature is to define, to render character more clear, to establish a face as a legible statement of character, whereas the effect of physical violence is the opposite, to undo, mess up, scramble the features and make it altogether a less readable face.

No, if you're looking for an artistic procedure that's comparable to *Marring a Face*, you won't find it in caricature. You'll find it – more nearly – in graffiti. The destructive, iconoclastic, graphic activity, carried out with pen, pencil, knife and gouge, that sets out to deface and mar and maul the image of someone's face.

Thomas 'Roly' Rowlandson (1756–1827) started as a promising painter but as a keen gambler too, he was always in need of funds. Inspired by the example of his friend Gillray, he turned to caricature and illustration. His big, popular hit was Dr Syntax, a character he created in 1809, spawning Syntax hats and Syntax figurines. He worked swiftly and travelled widely and his observational scenes from town and country satirised high life and low. A master draughtsman, his work is characterised by breezy, Rococo lines washed in gorgeous colour.

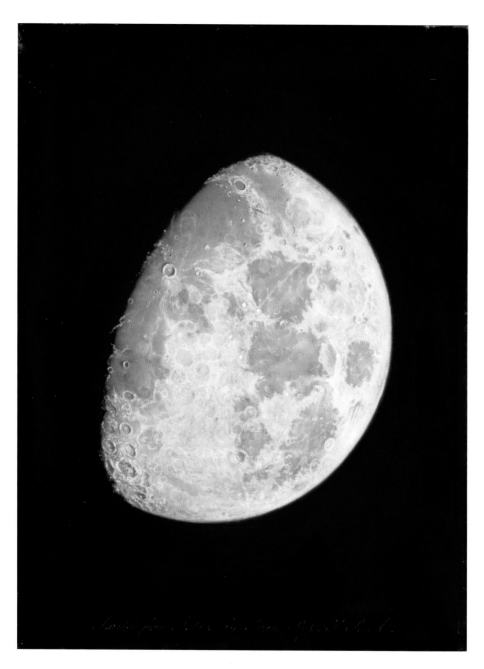

John Russell, *The Face of the Moon*, 1793–7
Pastel on board, 64.2 x 47 cm
Birmingham Museums and Art Gallery

THE FACE OF THE MOON

You can be in two minds about the moon. You may know very well that it is a globe like the earth, with part of its surface continually illuminated by the sun. As it orbits the earth, this illumination becomes visible to us in changing proportions, resulting in the moon's monthly cycle of phases – new moon, half moon, full moon etc. This has been understood since Galileo. All the same, it can be hard to jettison entirely the folkloric notion that the moon, as it changes its appearance, is actually changing its shape. It literally waxes and wanes, swells and shrinks. And the new moon really is a cut-out silver sliver.

The moon is torn between appearance and reality. What you can see usually doesn't square with what you know to be there. Except at full, a portion of the moon goes suddenly out of sight. What's visible is only part of the story. So it's a good subject for a picture, you might think – and it has been the subject for one very good picture, John Russell's superb pastel drawing *The Face of the Moon*. Russell was as well informed about the moon as a late-eighteenth-century person could be. He viewed his subject through a telescope. But his image is torn too.

It's a close-up of a waxing gibbous moon. That is, it presents the moon in one of its least familiar, least iconic states – not crescent, not full, not even a half moon. It's viewed at the point when it's just beginning to turn from a half moon to a full moon, a squat nut shape. Russell chose this phase because it shows up the moon's features best, and he observes faithfully this section of the lunar landscape. The terrain, with its dimpled planes and wrinkled ranges and pocked craters, is rendered with photographic sensitivity in whites and greys. The two large central dark patches are the Sea of Serenity and beneath it the Sea of Tranquillity (where the first moon landing took place in 1969).

The image holds contrary responses to our satellite. *The Face of the Moon* has no hint of a human 'face', no 'man' – but equally, for all its accuracy, it's far from being a mere map, an impassive record of the facts. It is a feelingful portrayal of what Russell called 'this beautiful object'. A mapmaker sets down detail starkly, graspably. Russell renders the softly glowing moon with a very gentle solidity. But he also takes a modern, scientific view. His moon doesn't hang in our sky,

shedding its mysterious light and power upon the world. It's not in a relationship to human life and destiny. It is without any divinity. It is indeed an 'object', an object of study and curiosity, a remote physical body isolated in empty space.

The space that surrounds it may look pitch black. At least, that's how it appears from some angles and in some reproductions. In fact, looked at closely, the background of this picture emerges as a deep and uniform ultramarine blue. But 'background' isn't quite the right word, of course. This blue doesn't just occupy the heavens behind the moon. It fills in a good deal of the moon itself. The darkened third of the moon is quite indistinguishable from the dark sky around it. There is not a trace or glimmer of the shadowed portion. As far as the picture is concerned, this part of the moon does not exist. And so the border between the lighted and shaded areas, the turn from the visible to the invisible, becomes the critical effect in this image.

The moon here has two kinds of curving edge, and the picture works hard to keep them distinct. There's the right-hand edge that represents its circumference, a regular semi-circular profile, sharp against the darkness. And then there is the critical left-hand edge that represents where the moon goes out of sight into obscuring shadow, a much trickier problem.

The disappearing act is beautifully handled. The fade-out is rapid, but not too abrupt. It conveys that the curving surface of the moon continues unseen, rather than suggesting (say) the rim of a cup. What's more, this edge is not a regular curve. It's slightly jagged with ins and outs, as the peaks of the mountains and craters just catch the last of the light. Though all you can see of this moon is its humped, gibbous form, the way it fades persuades you that this is a globe, partly lit and partly lost.

Yet the picture has a final twist. See how tightly *The Face of the Moon* frames its subject. Imagine this moon was suddenly full, a complete circle of brightness. On the left it would be cut off by the picture's edge. In other words, the subject of this picture is not the moon as such. There's no room for it. It's one particular phase of the moon that the artist has portrayed, that he places dead centre and makes the focus of this narrow image.

It's easy to imagine an altered version of the picture, a square rather than an upright oblong, with space not just for an illuminated moon-segment but for a whole moon. Its shadowed part would be invisible but (so to speak) all within view. You could peer into the darkness and imagine the lurking missing portion – both there and not there. But this is not what John Russell shows. His picture is fitted to this particular temporary moon-shape. Perhaps he does this for strict empiricist reasons, believing you should stick to the observable facts, concentrate on what you can see coming through the telescope and nothing more. Or perhaps he still feels the pull of the old folkloric idea, that the moon actually is as it appears to be.

John Russell (1745–1806) was a divided artist. The finest British pastel artist of his time, he was mainly a portraitist. One of his sitters was William Herschel, Astronomer Royal and discoverer of Uranus, from whom he bought a telescope and became a dedicated sky-watcher. The poor moon-maps of his time 'led me to conclude I could produce a drawing in some measure corresponding to the feelings I had upon the first sight of the gibbous moon through a telescope.' The picture here is a study for (or copy after) a much large image of the same subject, held in the Radcliffe Observatory in Oxford.

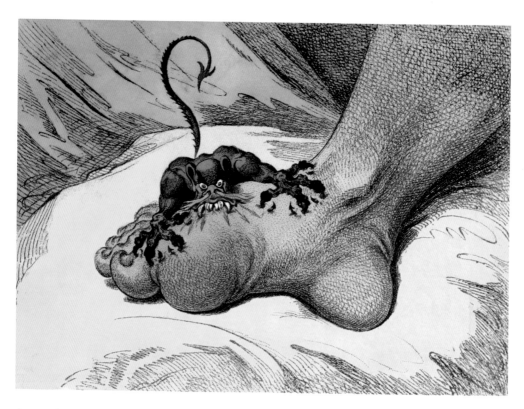

James Gillray, *The Gout*, 1799
Hand-coloured etching on paper, 26 x 35.5 cm
New College, Oxford

THE GOUT

In her final book, *Regarding the Pain of Others*, Susan Sontag wrote: 'It seems that an appetite for pictures showing bodies in pain is as keen, almost, as the desire for ones that show bodies naked.' There are certainly many shows of pain in western art. Christian and classical subject matter offer plenty of opportunities to artists and viewers. There are crucifixions, martyrdoms, infernal tortures, atrocities, assassinations, assaults . . .

But notice a couple of things about these images. First, their subject is not simply pain. They are specifically scenes of violence and violation. Somebody is doing injury, giving pain to somebody else. The pain is externally inflicted. It's a matter of wounds, blows, weapons, instruments, cruelty, victims. There are not many pictures of normal accidental injury, of people who've fallen or fallen over. There are not many pictures of everyday bodily pains, casual or chronic, that have no external agent – internal pains, headaches, belly aches.

And secondly, in these images the stress is usually on the whole body, the whole person who feels the pain. Pain is communicated by mouths in an outcry of distress, and by limbs writhing in agony. We're shown the expression of pain, not the physical sensation of pain. Our attention is on the victim, the sufferer, not on the body-part that hurts.

So pain in art tends to be made an interpersonal and soulful affair. This is art's way of taking pain seriously. Bodily pain, just by itself – even when it's utterly debilitating – doesn't get much respect from western culture. Psychological torment is dignified. Purely physical, animal suffering is 'meaningless'. It's not *about* anything. It's a dumb, brute fact. It can even seem rather funny, a humiliation joke.

Topping the bill in the traditional comedy of pain, above toothache even, comes gout. It's the rich, fat man's complaint. It is only just deserts for high living and self-indulgence. Gout is grotesque. What better subject for that master of satirical grotesques, James Gillray?

As a low, comic artist, Gillray was liable to fewer artistic proprieties about what he could depict, or how. Mockery was his first business, but he could mix up feelings in an extreme way. His forte was for making things simultaneously gross

and grand. *The Gout* promises a laugh at the distresses of privilege. It ends up as a comic homage to the power of pain.

It presents a hideously swollen foot, resting up, laid before us on a soft pillow. You see how the joint of the big toe – where the complaint generally strikes – is inflamed into a ball the same size as the heel, like a second heel. It stresses the uselessness of the foot. No longer a working, walking body-part, it has become a big problem area.

This cartoon, over two hundred years old, is perhaps the first close-up. Its protagonist is just a foot, and the foot claims the whole frame. This is a comically incongruous aggrandisement. (It distantly recalls pious images that dwell on the individual wounds of Christ.) At the same time, this framing reflects how – for the sufferer – the gouty foot looms large and separate, the pain filling the mind.

Notice its dramatic staging. In the top corner the leg is shaded, crosshatched, to the same density as the bedclothes behind it. It doesn't stand out from its background. But when it comes to the foot, suddenly there's a high contrast. The shading of the pillow seems to flee away from it, leaving it surrounded by an area of brightness. It's a spotlight effect. It puts a glow around the foot, an aureole. Here Gillray is depicting pain itself – not just the look of the inflamed foot, but its feeling, its hot throbbing torment, its untouchable sensitivity.

Gillray doesn't leave it there, though. Maybe he should have. Wouldn't it be a more perfect image if it communicated the foot's pain by purely pictorial means, if it didn't feel the need to externalise and allegorise this pain with the little monster of the gout-demon? There it sits, fastened on to the suffering foot, viciously digging in its fangs and its barbed talons (that have gone in and come out again), breathing darts of fire. It embodies gout's piercing and searing pains. Yet it seems to fall into standard ways of depicting pain, showing it as violation, not letting an internal bodily pain speak for itself.

True, really severe pain does feel like an attack from the outside, and the demon carries this psychological truth. But what's good about this creature is that it *isn't* completely separate and external. See how the bulging muscles of the monster – a visual simile that stresses the way pain becomes an active power –

pick up on the bulging inflammation of the foot. See how the knobbly notching of the demon's straining talons echoes the notching of the four smaller toes. The demon doesn't just assault the foot. It arises out of the foot. It fuses into the foot. Tormentor and tormented are one body.

The demon gives a face, an expression to the pain: even if it's the tormentor's, not the victim's. The simple presence of a facial expression allows an emotional focus/discharge that a faceless image would lack.

All the same, it's worth imagining the picture without its devil. Doesn't the foot by itself have sting enough? The distended roundness of the big toe's tip feels cut into by its toenail. Even the shading of the inflamed joint contributes. The cross-hatching doesn't just signify as shadow. It gives the skin there an extra tenderness, a scored abrasion, stretch marks. It adds to the image's intense sensation, its picturing of pure, excessive pain.

We may have an appetite for pictures of pain. But remember, some of these pictures are laughing at pain, and this laughter needn't simply be a cruel mockery of affliction. It has its sympathy. Pain, especially when you're in it, can feel like an absurd, gratuitous encumbrance upon the human condition. Affliction is itself a mockery. That's what Gillray shows, and he needs his battening devil. With its deranged expression, its barbed tail lifted in a quizzical flourish, it's there to keep the pain comic; not just painful, but funnily painful.

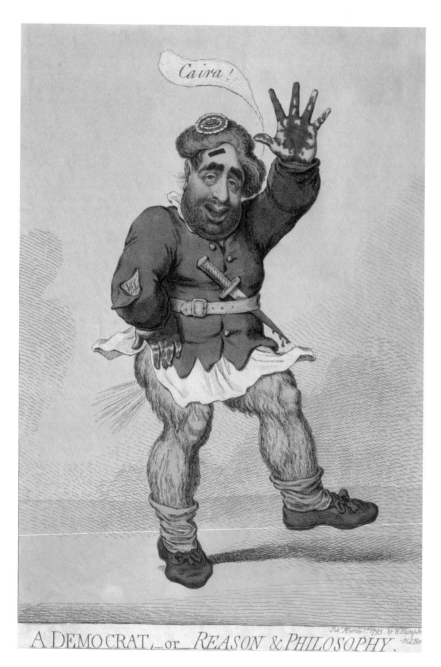

James Gillray, *A Democrat* or *Reason and Philosophy*, 1793
Hand-coloured etching on paper
New College, Oxford

A DEMOCRAT

There is an artistic effect that might be called 'breaking the surface'. It involves a kind of lurch out towards the audience. At a certain point, the work suddenly becomes more real, more immediate, more present. It speaks to you with startling directness. It doesn't feel like art. It grabs you. What was writing becomes a word spoken straight at you. What was an image becomes something you can touch.

For example, there's a frightening fragmentary poem by John Keats, 'This living hand'. It is the speech of somebody who's threatening to haunt somebody else from beyond the grave. Here's the whole of it:

> This living hand, now warm and capable
> Of earnest grasping, would, if it were cold
> And in the icy silence of the tomb,
> So haunt thy days and chill thy dreaming nights
> That thou wouldst wish thine own heart dry of blood
> So in my veins red life might stream again,
> And thou be conscience-calmed – see here it is –
> I hold it towards you.

After six lines of gothic blood-curdling, the shock comes at the end, in the last phrases: 'see here it is – / I hold it towards you.' They break the surface. The words really seem to hold out a hand to you, to thrust it in your face. It's as if a character on stage, delivering a soliloquy, suddenly turned and looked you in the eye and addressed you by name. You believe that he's there.

The shock is partly done with a style-shift, a change from a literary English to a much plainer and more direct English. Mainly it's in the way we relate to the speaker of these words. For most of the passage, he was just a voice, talking, a disembodied literary effect. But at the end he becomes a body, physically present: 'see here it is – / I hold it towards you.' You thought you were just listening. You hadn't realised – until this moment – that you and the speaker were visible and tangible to one another.

That's a poetic version. There are also pictorial versions. There are images that begin as a form of depiction and end up as something literal. They break through their surface and their pigment. Keats's hand reaches out of the passage and into our grasp. James Gillray's effects are even more material, more visceral. He offers a hand directly to our own hand. And his hand is steeped in blood.

The hand in question belongs to Charles James Fox. And from one point of view he was a distinguished Whig statesman, a hero of liberty. But not here. Here he is the opposite, a savage and jeering partisan caricature, a monster of the French Revolution. Gillray calls him *A Democrat* – the worse name he can give to him – the leader of a mob, a murderer. A caption adds further ironies: *Reason and Philosophy*.

This creature is a rough, dangerous and absurd figure. Gillray shows Fox with an animal body. His skin and his bulk make him grotesque. He is swarthy and sluggish and his face is oafish. He stands there, with a jaunty one-foot gesture. His hairy legs are like a werewolf. The caricature laughs at him, and he laughs back.

Fox bears the badges of the Revolution. He shows the behaviour and the costumes of the People. His bare-arsed appearance dignifies the 'sans culotte' uniform (the expression is figurative; the crowd wore these short trousers). His shirt flies out and he farts into the wind. In a speech balloon, he cries out the citizen's bloodthirsty song: 'Ça Ira!' 'We will string up the aristocrats! We will win, we will win, we will win.' And on his wig he pins his tricolour cockade – red, white and blue.

These three colours are the Republican symbols of liberty, equality and fraternity. But they are also made – ironic again – a visual theme in this image. Fox's jacket is blue and his shirt is white. Meanwhile, the blood on his knife and hands is red. His right hand is posed on one hip like a hornpipe. The left one is raised up like a salute, spattered and sticky with gore, and hailing the viewer in the jolly, enthusiastic spirit of massacre.

Blood, blood, blood. Or as Keats put it: 'see here it is – / I hold it towards you.' This is where the picture becomes specifically violent. This is where 'breaking the surface' occurs and touches our own hands. Fox's left hand is the crucial thing. Five

fingers are spread wide. His palm is turned flat to the front of the gesture. His palm is also set face-on to the flat surface of the image itself.

Gillray has created a beautiful shock. The point is that, not only Fox's palm but the blood on it too, is laid flat to the image. Blood becomes literally the medium of this print. The stained surface is equated to the ink-marked page. Red blood is red ink. The fictional blood of this drawing is here as real as the tangible ink on the page.

His hand, our hand, and between them the paper, and the blood-cum-ink lying on it . . . We could physically run our fingers over this surface. Or coming at it the other way, Fox's murderous palm is pressed incriminatingly on to the page itself. So the two points of contact become one, in both pleasure and cruelty. It's clear that Gillray's caricature is more than morality or offence. He richly delights in his outrage and invention and horror and comedy. His genius breeds monsters.

James Gillray (1757–1815) was the creator of the modern political cartoon, and much more. He lived above the London print shop that distributed his work. His subjects were social, party political and ideological: Pitt and Napoleon at the table, with the world on a plate between them, carving it up; the Prince of Wales immobile with food; diabolical Jacobins in cannibalistic ecstasy; treacherous Paddies, honest, doltish John Bull. His satire was generally anti-democratic. He had a taste for physical gross-out. His images were vicious, viscous – and visionary. He was an artist manqué who filled his caricatures with high art references and could out-sublime all the painters of the Royal Academy. Critics, baffled, compared him to Michelangelo.

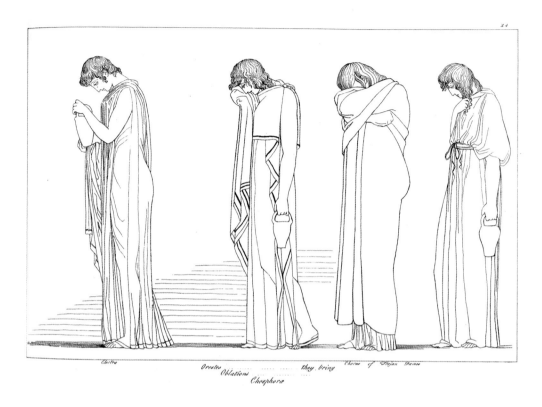

Thomas Pilori after John Flaxman, *Electra and the Chorus Bearing Vessels for Libation on the Tomb of Agamemnon* from *Classical Outlines*, 1795
Engraving, 22.5 x 16 cm

ELECTRA AND THE CHORUS

Less is more – and more, and more. In the last century, minimalism in art has thrived. But the first great outbreak of less occurred around two hundred years ago. There was the cult of pure outline. And there were few purer linesmen than John Flaxman.

Flaxman's graphics took their visual inspiration from ancient Greek pots, and his subjects were often drawn from ancient Greek poets. He used a very reduced vocabulary of lines and wide white spaces. The prints made after his classical compositions, engraved by Thomas Pilori, are a demonstration of what linear economy can do. But like any minimalist art, his work has aroused doubts too. Perhaps less really is less.

This is one of his most severe compositions. You hardly need to know the plot. It illustrates a scene from a Greek tragedy, Aeschylus's *The Choephori*. It shows a procession to a grave. *Electra and the Chorus Bearing Vessels for Libation on the Tomb of Agamemnon* is the title, but this file of mourning women could be an all-purpose war memorial image. It's clear, at any rate, what sorts of feelings are involved.

But sometimes it's maintained that Flaxman's minimal art can't do feeling. It may be technically brilliant, translating everything into its limited code of lines. It may create an ideal world, where everything is perfectly clean and simple. But it's simply too economical and too rigid to move us.

Here are some modern critics. Erwin Panofsky says: 'Reduced to pure contours, the visible world in general, and the relics of antiquity in particular, seemed to assume an unearthly, ethereal character, detached from the material qualities of colour, weight and surface texture.' Robert Rosenblum says: 'Flaxman's style, which flattens and schematises all forms, whether clouds or children, in the interest of geometric and linear purism.' James Hall says: 'A puritanical impulse underpinned these editorial purgations . . . His engravings have cheese-wire outlines, and no shading or cross-hatching. Their limpid but rather prim simplicity'

These remarks have a clear thrust. Pure, flat, schematic, geometric, unearthly, ethereal, prim, puritanical: Flaxman's art denies us the solid, pulsing flesh. It's bodyless, heartless, sexless, weak, empty, inert.

Wrong. These critics don't see where the power of this art lies – its physical power. Their basic mistake is to assume that Flaxman has a style, which he applies uniformly. They suggest that he reduces *everything* to pure contour. But if contour means the kind of line you would trace round the very outside edge of a body or object, then evidently that's not true.

In *Electra and the Chorus* you can see Flaxman using diverse types of lines. Some of them are total contours, which mark the surrounding edge of an entire figure. Some are subsidiary contours, which go round an arm or jar, within that. Some delineate the hem of a robe, or the tucked pleats of a robe, or the stripes on a robe. Many lines stand for crinkles of hair. At one point, there are wiggly lines that mean single strings twisting from a knot.

What's more, the economy of these lines varies. In some places empty contour is doing a lot of the work in establishing the figure. Elsewhere many other lines fill in, adding internal detail. Some figures, in other words, are much more minimal than others. And these fluctuations are not random.

Follow the procession along, left to right, figure by figure. With each one, the linear treatment changes a step. The leading figure, Electra, with her densely pleated diaphanous veil is the most detailed. The second figure is made of purer contours, and the third is even more pure. Then in the fourth a level of detail returns. In terms of economy there is a rising crescendo, with a final lowering.

This sequence coincides with the emotions of the figures. Their grief body-language follow the same crescendo. The first woman holds her head visible, the second partly covers her, the third has hers fully buried, and the fourth is back up in sight. Likewise their stances: the first relatively relaxed, the second more pressed together, the third rigidly clenched together, the fourth again more relaxed.

That third figure is the emotional and pictorial climax: the point of maximum grief, and the point where the drawing opens out to become most economical and geometrical. The focus of the whole image is the large empty area in this figure's robe, partly bounded by the continuous and regular curving contour of her bottom, thigh and calf.

Its emptiness fills with pressure. It's under contained tension. Literally, we can suppose that the robe of this clenched figure is stretched tight against her skin. Metaphorically, it's as if her straining grief had squeezed the detail out of her, reducing her almost to her edges only. *Electra and the Chorus* enacts a powerful movement of intensification, tautening – and where its lines are least, its power is most.

John Flaxman (1755–1826) was the most influential English artist of his age. Primarily a neo-classical sculptor, he made public monuments and memorials for churches, designs for the Wedgwood pottery and vivid observational drawings. But his most distinctive works were a series of 'outlines' – extremely economical compositions illustrating ancient authors and Dante, using a style that looked back to the greater purity of classical and early Renaissance art. Through printed versions engraved by other artists – including by his lifelong friend William Blake – the impact of these images was continental, providing blueprints for pictures by David, Goya and others. His heirs are those later fine linesmen, Aubrey Beardsley and Patrick Caulfield.

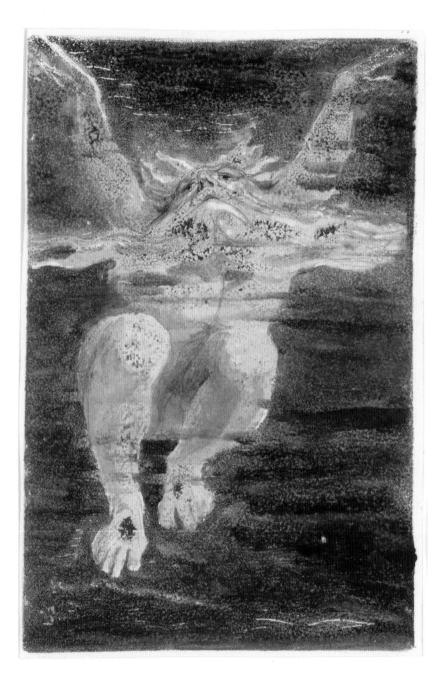

William Blake, from *The First Book of Urizen*, Copy D, plate 11, 1794
Relief etching with colour print and watercolour, 15.4 x 10.2 cm
British Museum, London

BLAKE SHAPES

William Blake, was he a nudist? There is just the one story. It comes from the 1790s, when Blake and his wife Catherine were living in Lambeth. There was a printing press in the front room (this was the decade of *Songs of Experience, The Marriage of Heaven and Hell*, among other great works). And in the garden there was a vine-covered arbour.

One day a friend called – and 'found Mr and Mrs Blake sitting in this summer-house, freed from "those troublesome disguises" which have prevailed since the Fall. "Come in!" cried Blake; "It's only Adam and Eve you know!" Husband and wife had been reciting passages from *Paradise Lost*, in character, and the garden of Hercules Buildings had to represent the Garden of Eden, a little to the scandal of wondering neighbours, on more than one occasion.'

That's the story, and pretty amiable it seems. But it is not first hand. Some of Blake's biographers believe it. Some firmly disbelieve it. Back when the image of 'Mad Blake' still obstructed appreciation, there was an understandable wish to play down any sign of eccentricity. And some simply aren't sure – but are sure all the same that, even if it did happen, it 'tells us nothing significant' about Blake. Really?

Now, of course William Blake was not a nudist, not as we understand that today. Modern nudists sometimes cite Blake as a great precursor, but both the word and the movement are twentieth-century inventions. It's true there were various fringe religious groups who practised principled nakedness, and Blake might have got the idea from there. But then, as the story makes clear, the idea of a life without clothes wasn't hard to come by – it was in the Bible, in Milton.

And even if the tale is untrue, it's still significant. It's like a good joke about Blake. It touches on many sides of his work – on the themes of innocence and experience, for example (and when Blake printed the *Songs of Innocence and Experience* in a combined edition, the title page had an illustration of Adam and Eve – innocence now lost, shamefully clothed in leaves). It reflects his lifelong devotion to the poetry of Milton, here getting an undress rehearsal.

The human body was Blake's central artistic subject. As he once declared: 'Art can never exist without Naked Beauty displayed.' And he had strong views about it. In May 1809 Blake exhibited his largest painting – fourteen feet by ten. Now

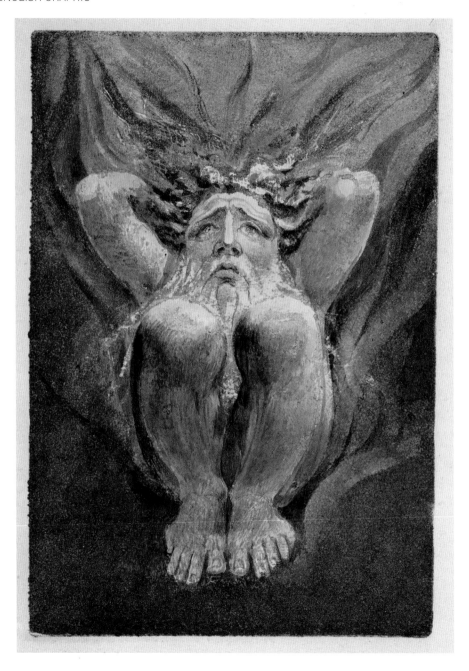

William Blake, from *The First Book of Urizen*, Copy A, plate 21, 1794
Relief etching with colour print and watercolour, 25.4 x 18.1 cm
Yale Centre for British Art, Paul Mellon Collection

lost, *The Ancient Britons* showed three, naked, over-life-sized figures. He wrote about them in his *Descriptive Catalogue:*

> The flush of health in flesh, exposed to the open air, nourished by the spirits of forests and floods, in that ancient happy period, which history has recorded, cannot be like the sickly daubs of Titian or Rubens. Where will the copier of nature as it is now, find a civilized man, who has been accustomed to go naked. Imagination only, can furnish us with colouring appropriate, such as is found in the Frescos of Rafael and Michael Angelo: the disposition of forms always directs colouring in works of true art. As to a modern man stripped from his load of clothing, he is like a dead corpse. Hence Rubens, Titian, Correggio, and all of that class, are like leather and chalk; their men are like leather, and their women like chalk, for the disposition of their forms will not admit of grand colouring; in Mr B's Britons, the blood is seen to circulate in their limbs; he defies competition in colouring.

What I like about the story in the garden is specifically the aspect of impersonation – and the emphasis this puts on Blake's own body. Here are William and Catherine, acting at being Adam and Eve in their original state. It would be an ambitious feat of imagination, if you think about it – not just a matter of shedding clothes, but feeling oneself into the lives of the first two human beings in the world, with bodies newly created by God. It's as if Blake was entering into the strange and not-quite-human, bodily life of his own visual fictions.

That would be some feat too, given how strange a life this is. And really I was wrong to say that the human body is Blake's central artistic subject. It is certainly his chief pictorial resource, but that's another matter. There are thousands of bodies in Blake, but only a few of them mean the everyday body. There's a sense in which Blake doesn't believe in the physical human body. But whatever spiritual force or state Blake wants to show, he represents through some version of the human form. It is his all-purpose symbol. Almost as a by-product of this, his art becomes a comprehensive experiment with the human form.

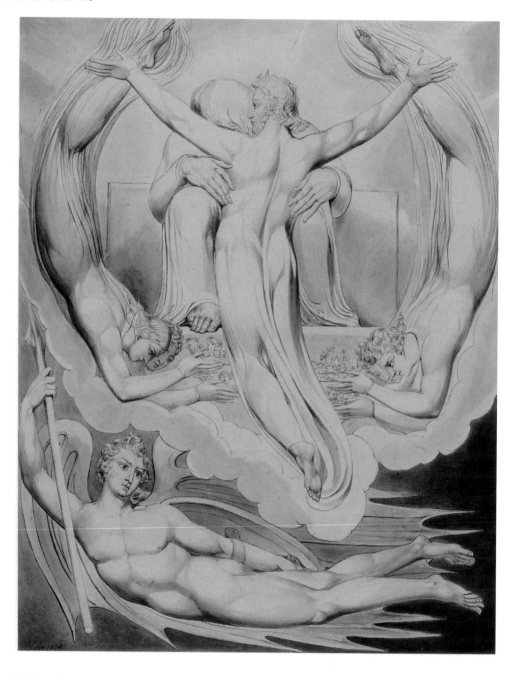

William Blake, *Christ Offers to Redeem Man*, 1808
Pen and watercolour, 49.6 x 39.3 cm
Museum of Fine Arts, Boston

Yet does Blake really enter into these figures, and imagine what they'd feel like? This seems to me the central issue of his visual art. The visions are amazing, but – and it's a general problem of visionary art – they can also seem very sealed-off and solipsistic, just someone's made-up world, because they have it all their own way. It is an art that meets no resistance in reality.

You can see the point, if you compare Blake with his great contemporary Goya. There are fantastic scenes in Goya, but the strange creatures are drawn from a solid reality. He always makes you feel they could work. As Baudelaire said: 'The great virtue of Goya consists in creating a monstrous kind of verisimilitude. His monsters are born viable . . .'. But with Blake's art, while its main components are bodies, they aren't really bodies – just the infinitely amenable figments of his imagination. Or rather, this is the question for Blake's figures. Does he imagine them as real bodies, however strange? Or are they simply means at his disposal?

In Blake, a body is always a body-in-a-certain-position. The figure is subordinate to its configuration. There is never a sense that a body happens to be in particular pose. It *is* that pose. A developing repertoire of body-configurations is the basic currency of Blake's work, and they're not hard to identify. Leading examples include: the figure with expansively outflung arms, the figure withdrawing into a knot of limbs, the figure in a sideways hair-pin bend.

In Blake's art, the body is put through drastic contortions, extensions and elisions. Think of those extraordinary bunched-up, head-in-knees figures, for example the character from Blake's personal mythology called *Urizen*, symbol of repressive Reason. There's no real three-dimensional body there – it's just a construction of assembled head and limbs. It's impossible to imagine this figure stretching a leg, standing up. It is identical with its constrained, defensive shape, its particular mould. It's just an image, and could only be an image. And it's the same with Blake's more energetic archetypes. They too are made for their stencils.

Blake's bodies are not just stretched, crunched and edited. They aren't really made of flesh and bones. Often, it seems that they have no skeleton, that they're spineless fillets, whose articulation is not so much disjointed as unjointed – fluid and flexible creatures like an otter or a tadpole.

Or again, flesh and clothing often seem to interfuse. The flowing, transparent robes of a figure become at some points indistinguishable from its musculature, and at others to be an extra layer around it, an emanation, an ectoplasmic body-extension or bag. Even naked figures appear to wear their bodies as a kind of sleek membrane.

All of which points to a central fact about these bodies. Their 'insides' are not the important thing. Their most vital feature is their outside edge. With Blake's figures, as with the amoeba, identity is contour. I mean specifically the outline that bounds and defines the figure. Their body-parts are secondary. The overall shape they make, the shape they fill, is essentially what they are – whether their bodies twist like flames, curl like tendrils, roll up in ball, or entirely lose themselves in the echoing forms of the surrounding design.

So the impulse to describe these bodies as fillets, or even as spirit mani-festations, is mistaken. It's being too realistic. It's applying three-dimensional standards where they don't apply. These contour-defined figures are inherently two-dimensional beings: only flat images have outlined edges.

It's the same with the sense of weightlessness. Blake's bodies are certainly light. They leave the ground at a drop of a hat. But figures in art can defy gravity in a variety of ways. They may jet like Superman. They may levitate like a moon-man. They may fly like a kite. Blake's figures have their own peculiar weightlessness – they are like divers, with underwater buoyancy. They move up or down or around, under no pull at all, in a perfectly free medium.

But really what they are swimming about in is not any space, but on the page. Gravity doesn't apply. They are no more weightless than the dot on an 'i' is weight-less, or any letter. This is one of the big effects of Blake's illuminated books, where figures and writing mingle together in the same area: to suggest that the figures are as free as the words.

These bodies are creatures of the page. Most of their distinctive features – the configurations, the contours, the free motion – are things that can only be true of two-dimensional figures. The two-dimensional is a supernatural realm, in which impossibilities become possibilities.

Blake's great artistic discovery was the potentialities of two-dimensional life. But the risk is evident. A sense of a feeling body will be abolished. The human form will become a token, a bit of diagram, a versatile but empty symbol. And sometimes this happens with Blake.

But there are pictures, and they are Blake's best, where his two-dimensional inventions take you not away from bodies, but into them and out the other side.

In one of his illustrations, to his poem *Jerusalem*, for instance, there's a couple embracing in the cup of an open lily. The effect is all in their fluid contours, which both establish their identities and utterly merge them, making these bodies into a single continuous organism, folding them into the petals of the flower, and into each other, in a totally absorbing embrace.

It's a fine line, and I'm not sure I know what makes the difference – what turns Blake's two-dimensionality from something flat to something piercingly felt. But I'm sure it is the crucial difference in Blake's art. On the one hand there's a slightly gimcrack universe of fantasy figures. On the other, his images enter realms of bodily feeling that almost no other art can reach.

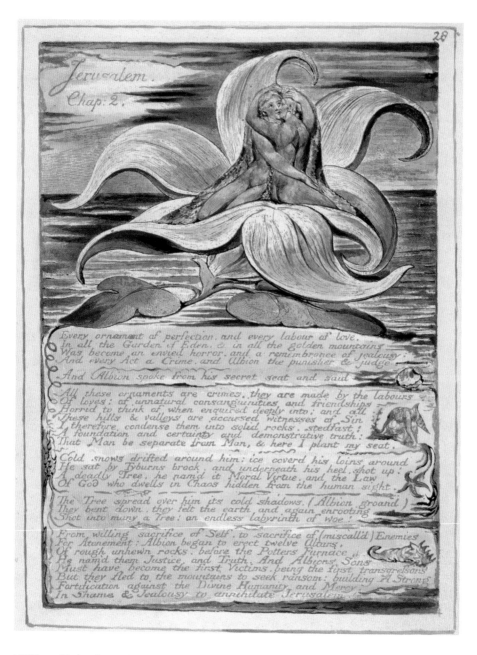

Jerusalem.
Chap: 2.

Every ornament of perfection, and every labour of love,
In all the Garden of Eden, & in all the golden mountains
Was become an envied horror, and a remembrance of jealousy:
And every Act a Crime, and Albion the punisher & judge.

And Albion spoke from his secret seat and said

All these ornaments are crimes, they are made by the labours
Of loves: of unnatural consanguinities, and friendships
Horrid to think of, when enquired deeply into; and all
These hills & valleys are accursed witnesses of Sin.
I therefore condense them into solid rocks, stedfast:
A foundation and certainty and demonstrative truth:
That Man be separate from Man, & here I plant my seat.

Cold snows drifted around him: ice coverd his loins around
He sat by Tyburns brook, and underneath his heel, shot up:
A deadly Tree, he namd it Moral Virtue, and the Law
Of God who dwells in Chaos hidden from the human sight.

The Tree spread over him its cold shadows. (Albion groand)
They bent down, they felt the earth, and again enrooting
Shot into many a Tree: an endless labyrinth of woe!

From willing sacrifice of Self, to sacrifice of (miscalld) Enemies
For Atonement: Albion began to erect twelve Altars,
Of rough unhewn rocks, before the Potters Furnace
He namd them Justice, and Truth, And Albions Sons
Must have become the first Victims, being the first transgressors
But they fled to the mountains to seek ransom: building A Strong
Fortification against the Divine Humanity, and Mercy,
In Shame & Jealousy to annihilate Jerusalem.

William Blake, from *Jerusalem The Emanation of the Giant Albion*,
Chapter 2, plate 28, 1804
Relief etching with pen and watercolour, 22.2 x 16 cm
Yale Centre for British Art, Paul Mellon Collection

JERUSALEM THE EMANATION OF THE GIANT ALBION

Here's a beautiful two-liner, by the nineteenth-century poet Thomas Lovell Beddoes:

A lake
Is a river curled up and asleep like a snake.

It's like a dictionary definition. A word is given, and then its meaning is unpacked. Or perhaps uncurled. The shape of the couplet mimics its subject. The compact first line uncurls into the long second line (and by English verse standards it is a long line, a twelve-syllable Alexandrine). Lake stretches out into snake.

But it's hard to say whether the epigram is more about lakes or about snakes. It says that every lake contains a coiled-up river, a river that's still there, even though its banks are lost, and even though – unlike a snake – it can never uncoil itself again. That's an interesting way to feel about a lake. But equally, it suggests that a snake, when it's curled up and asleep, is like a lake, because a sleeping snake *does* (in a way) lose its banks, its sense of its own bodily boundaries, and becomes fused into a single pool of sensation. The simile works both ways. And what the poem makes you feel about the sensations of snakes is probably the more piquant effect.

Also possibly untrue, of course. Maybe the life of snakes isn't like that at all. But you can imagine it *could* be like that. When a snake is all wound up and interlooped, the skin's sense of touch, and the body's proprioception of its position, might well generate confusing signals about what was what, and where – all the more so, if the snake is sleepy. Even with humans, very low levels of consciousness lead to a vagueness about the difference between different body-parts. Our sensory banks blur. We flow into ourselves. And when two humans are closely intertwined that can breed further confusions about what's mine and what's yours.

There's an image by William Blake that holds one of the closest embraces in art. It comes from Chapter 2 of his illuminated poem, *Jerusalem*. As with most of Blake's illustrations to his own and other people's writings – in fact, as with any good illustration – there's a considerable distance between the picture and the words. In the body of the text, the giant Albion is denouncing 'unnatural consanguinities and friendships horrid to think of' but at the top of the page there is this extravagant image of love, two bodies enfolded in the cup of a lily. You could try to make it fit with the poem in various ways. But it speaks so much more powerfully than the poem, that whatever the connection might be, is a matter of secondary interest.

Blake's great artistic discovery was the potentialities of two-dimensional life. No artist before him understood so clearly the uses of the flat page to create a transcendental world, a world in which things are simultaneously material bodies and spiritual forces. In this image he takes the idea of sexual/mental/physical union and gives it an irresistible shape.

The two enfolding figures (and they may be both women) are certainly distinguishable. You can see which limb is meant to belong to which body. Yet at almost every point their forms are designed to slip into and pick up on one another. They are bonded together in a single continuous curvaceous shape. Their long flowing streams of golden hair contain them, and in the arc going over their heads the edges of both these tresses, and the edges of both raised forearms, converge and coincide as a single curving edge. The outline of an arm flows into the outline of a thigh. Their lips are sealed together to make a single mouth. There are several other, almost subliminal joins and ambiguities. Curled up, curled round each other, they lose their banks and boundaries and fuse into a single flesh. Only a two-dimensional image could do this effect so strongly.

More alarmingly, there's a similar slippage between the undulating lines of their shared form, and the undulating shapes of the lily's petals. We're to feel that the humans are not just bedding down in the lily's cup, they are physically emerging from it, merging into it. Animal is fused with vegetable. They're an integrally, organically growing part of this lily.

This is a strange sensation. It breaks a powerful taboo. Standard metamorphosis legends have many stories about humans *being turned* into vegetables, but that's a different matter. These transformations always mean the end of the human life in question. Daphne becomes a laurel tree. She may be pictured at the moment of transition with leaves growing from her arms and roots from her feet. But she doesn't continue to live in this halfway state. She rapidly becomes all tree, and grows in the ground.

What Blake shows is that these lovers are fused to their lily, *alive*. Animal and vegetable are symbiotic. One may well agree with Albion about 'unnatural consanguinities' (though the poem doesn't mention anything like this). It's like the mandrake, the horrible humanoid creature that grows as a root in the ground and screams when uprooted, fatal to the hearer.

Or maybe there's a more high-minded thought at work – that the union of lovers is at one with the union of all living things, that separation is the great evil, and that love is a great big merge, between individuals, across species barriers, everything – a thought that's here given an uncomfortably palpable realisation. Or maybe the picture is just about the homely feeling of snuggling up, and feeling the bedclothes as your safely cocooning nest. The petals do look a bit like sheets.

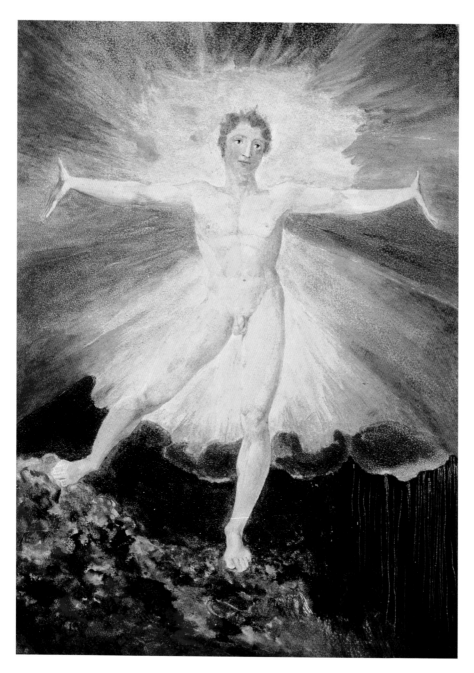

William Blake, *Albion Rose*, 1796
Colour-printed etching with ink and watercolour, 26.5 x 18.8 cm
British Museum, London

ALBION ROSE

This is a hypothetical image for a hypothetical day. It's an affirmative vision for a moment that's very unlikely to be now. Even in its own day, it was highly optimistic. William Blake's *Albion Rose* can only feel like a cruel irony or a bitter protest or an impossibly remote ideal.

Albion is England, a personification of this island. In this picture – also known as *Dance of Albion* or *Glad Day* – he symbolises England's political awakening and liberty. A naked man stands on a rock in a sunrise, rising above the material world, welcoming the dawn. This elemental scene was coined at a time of revolution and repression, and Blake added captions to focus his meanings. Pictorially, there's nothing to set it in any specific age or place or politics.

All the same, Albion represents a uniquely utopian figure. His body itself speaks an abstract but articulate language. This nude is delivered from all bondage and all untruth. He is beyond conflict, beyond struggle and inner struggle, wholly realised. And yet this figure isn't stuck in final utopian lifelessness, as you might suspect. He holds an interplay between static pattern and dynamic tension.

Stasis first. The figure is a centrifuge. Its energy is fully released. It's the polar opposite to another static form, often used by Blake – a human body self-imprisoned, totally compacted into a ball or a block, its power pent up and contained. Albion goes all the other way. His body is flung outward. His limbs unbend and reach out as far as they can, and each limb is free of others. He is absolute liberation.

The figure is innocent. It has no sophisticated classical complexity, no graceful twisting of torso and stance. The naked body lies on a single plane, and it faces full frontal. Its arms are not raised in victory either, but level and opened to the world. The figure is at the point of maximal unfolding. There is no potential in this pose, no compression, implying something further. This stance is fully actualised. It has arrived, now!

This is the figure's utopian aspect: its uttermost unfolding, its extreme openness and unboundedness. And this simple pose is what gives it an archetypal power. The body is identified with a bold clear shape.

But if that was all there was to it, this figure would only manifest a perfect and inert simplicity. And when you observe Blake's archetypes, it's clear that the form

of unboundedness could be just as rigid a stencil, just as programmatic an idea, as his opposite form, the figure of bondage. Either figure – bound or free – is equally stuck down as regular template. One would be a contained moulded block. The other would be cast as a human starfish. Both would lack any feeling of desire and spontaneity. The difference would be only that this figure of freedom is meant to be free.

Albion eludes this strict stencil. His figure has dynamic elements. For example, his pose is centrifugal, but not altogether. There is still strain in his gestures. His hands don't stretch right out, they are flexed right back. They indicate that Albion still wants more, more. He's trying to embrace the world, more than he can embrace – or trying to display his body, more than he can display. His reach exceeds his grasp.

Meanwhile, his legs break a stable symmetry. One stands upright and supporting on the rock; the other is on the wing, lightly and gracefully touching down. The body's weight is uneven. The foot begins to lift. The head is slightly turned. Action enters the figure. *Albion Rose* is in the middle of a dance step, and its level arms are keeping its balance. It might be on the point of a spin. So the utopian figure is saved from being fixed and rigid. It is still aspiring and still moving.

And then a pattern returns, and at another level. This image has a ruling design, a radiant structure, which incorporates the whole figure and all its limbs and everything. Arms and legs emerge like the spokes of a wheel, roughly centred on the diaphragm, but it's not merely a matter of the anatomy. The crucial device here, never used by Blake elsewhere (or by anyone else) so explicitly and so strongly, is the equation between the body and its background.

The out-flung stance of Albion is picked up and drawn out by the radiating beams around him – his own shining aura, perhaps, or an entire sun-bursting sky – which is also a multi-coloured flame and a flowering and a butterfly wing. Likewise the glowing substance of Albion's flesh is on the point of physically merging with this radiance, so that the body could be materialising out of light or dematerialising into it, and the energy of the body is at one with pure energy. His head explodes into a flare.

Albion is in glory. England is in union with the universe. All worldly politics is dazzled. Who could ever imagine this glad day on any morning, or dare to frame this image on any public poster? It could only be propaganda for a party of apocalypse.

William Blake (1757–1827): painter, printmaker, visionary, myth-maker, religious and political radical, aphorist, poet. But for all his multiple accomplishments you never find anyone calling him a 'Renaissance man'. He's not respectable enough for that title. The shadow of eccentricity falls on his greatness. His visual work, for example, is an unresolvable blend of staggering originality and limitation. He trained and worked as an engraver and illustrator. He weirdly mixed the influences of Michelangelo and Gothic art – and mixes up text and image even more inextricably than a medieval manuscript. There's a sense in which he can't draw. His colour schemes are unheard of. His images are stuck in a sealed-off, home-made myth world. His human figures are always spiritual symbols – and in the process, his art becomes a comprehensive experiment with the human body whose only parallel is in Picasso.

DEFINING THE VIGNETTE

A revelation. 'I sat down with Mr Blake's Thornton's Virgil woodcuts before me, thinking to give their merits my feeble testimony. I happened first to think of their sentiment. They are visions of little dells, and nooks, and corners of Paradise; models of the exquisitest pitch of intense poetry.' It was Samuel Palmer who sat down with these late Blake images before him, and found in their small print an abundant source of inspiration. Visions of little dells, and nooks, and corners of Paradise: are these the terms for Bewick's vignettes too?

They were close contemporaries. There is common ground. Thomas Bewick: 1753–1828; William Blake: 1757–1827. In his illustrations to Virgil's *Eclogues* Blake uses Bewick's medium, end-grain block printing, perhaps under remote influence. The Blakes, though not vignettes, are about the size of many of those that Bewick added to his books of animals and birds: seven and a half centimetres across.

Blake's *Blasted Tree and Blighted Crops* (top left) from Thornton's *Pastorals of Virgil*, and Bewick's *An Angler with his 'Set Gads' on a Riverbank* from *Water Birds*: two desolate scenes, with the wind and the rain and a bending tree, but with marked differences between them too, and in more than the presence of a moon or a shivering fisherman.

Look at Blake's tree and at Bewick's. They're of distinct formal breeds. Blake's forks in diminishing horned curves. Bewick's grows in a knobbly, spindly spread. Blake's belongs to no natural species, is made on an archetypal template. Bewick's is an ash stump, with a sprig of younger branches sprouting, observing nature's irregularities. It's the difference between a visionary classicism and a vernacular empiricism.

But Bewick's art of observation holds revelation too. It lies where Palmer found it in Blake – in the minute. The size of the image is part of its force, and here Bewick goes further. The Blake motto, 'to see a world in a grain of sand', almost applies literally to Bewick's microscopic depictions. His images are more faithful than Blake's are to 'minute particulars', both in their knowledge of nature's details, and in their mastery of engraving at a miniature level. Their wonder lies, not in vision, but in eyesight. Viewed at actual size, unmagnified,

their reductions may elude the eye. They aren't pictures to be known at a glance. Their scale makes them a kind of secret, to be probed. They wait to be disclosed, under steady attention . . . and reward this attention when the eye reaches in and at last grasps their finely cut minutiae. You're conscious of a jump of visual gear. The invisible becomes visible. Close-up, the image reveals the (at first hidden) molecular layer of clear and distinct black-and-white marks out of which it's constituted.

Miniature landscape can contain a particular revelation. Almost all of Bewick's vignettes are outdoor scenes, and in many of them, beyond the foreground stage, the view gives on to distances, inviting our gaze to cross miles towards the horizon.

The eye enters into the little image, adjusts, finds its scale, and then travels out into that remote and expanding vista – over the hills and far away – as if you'd put your eye to a glass or your ear to a shell.

The vignette, in one definition: 'an illustration . . . that fades into the space around it without a definite border.' Bewick himself neither defined nor announced his great origination. The vignette slips quietly by in the *Memoir*. But his minute images break a rule of picture-making established since the Renaissance. As Alberti stated it: 'On the surface on which I am going to paint, I draw a rectangle of whatever size I want, which I regard as an open window through which the subject to be painted is seen.' Bewick's innovation is to remove the window. The scene is not bounded by an oblong edge. It's not viewed through a frame.

The vignette may have lost its open window. That still leaves many things open. It has a defining contour, and this contour may be firmer or vaguer. It has some sort of shape. Its shape may be more or less irregular. At their edges Bewick's vignettes sometimes thin away, gradually disintegrating into fringes and sprinkles of lines; they never fade out with perfect smoothness; sometimes they come to an abrupt stop. The scene normally takes the form of an approximate oval, set on its side. The coastlines of these ovals can be very rough and fluctuating.

The overall shape of a vignette is part of its effect. The rounded formations of Bewick's vignettes mean that, seen from a distance, or out of focus, they

often lie on the page like a smudge or a spillage. Their sharper forms dissolve. What you see are pools of tones, which might have been set down loosely and sketchily in brush and wash. A slow, dry art comes to resemble a quick, wet art. Description turns to abstraction. There's an echo of another contemporary English graphic artist. Bewick's vignettes are like Cozens's blots in reverse. Their depictive intentions are fully realised. But with their fluid, nebulous contours they look like free-formed areas, as if an arbitrary or random impulse made the going.

Another vignette effect. The unframed scene casts landscape into a new kind of subject. The view is not given an off-the-peg edge, independent of and indifferent to its contents. It is given a bespoke edge that responds to and defines the character of the scene.

The vignette crops and hugs a group of significant features – tree, bank, rocks, bushes, water, church – and presents them as the scene's distinguishing marks, while leaving out whatever isn't relevant. It is place-portraiture. It declares the profile or physiognomy of a site, isolating those elements by which you would know it again. In such images, Bewick isn't a landscape or nature artist. He's a local artist. His subject is the specific spot, the nook, the familiar and recognisable corner, the scene that has a face and a name.

The vignette's irregular contours may even lend it a visionary aspect – or comic-visionary, at least. The scene unfolds, rolls back, opens up, like an apparition in cloud or smoke. Bewick's images relate to another visual form of his time. They offer a print-miniature version of a popular spectacle, the 'phantasmagoria': a lantern projection entertainment, often showing some nightmarish subject. And moonlight, spooks and devils fill Bewick's imagination too.

The vignette creates a reality effect. The image appears as real as the physical medium, the ink and the paper, that it's made of. It happens in two ways.

Without a frame, we do not look through at a depicted world. There is no window to set the scene back behind it. The image lies on the surface on the paper. A figure, a tree, a bush, is identified with the printed marks on the page. Alternatively, without a frame to delineate the image, there is no division between the picture and the paper around it. The scene materialises out of the surrounding page. One way, the image breaks the paper surface; the other way, the image gathers and condenses out of the blank page.

Charles Rosen and Henri Zerner describe the phenomenon: 'The image, defined from its centre rather than its edges, emerges from the paper as an apparition or fantasy. The uncertainty of contour often makes it impossible to distinguish the edge of the vignette from the paper: the whiteness of the paper, which represents the play of light within the scene, changes imperceptibly into the paper of the book, and realises, in small, the Romantic blurring of art and reality.' Or it might not be the play of the light, but the white of snow.

A man lolls on a grassy bank, in a little dell of helpless, drunken happiness. He nestles in his image as in a cradle, or as if held in a cupped hand. But Bewick is also drawn to lonely and pent-in states. A man travels across terrain in wet and darkness, literally unable to see far, and psychologically engulfed by his immediate fate. He may be on the move, but he's enclosed. What we see is not the land he's traversing. It's the patch of the world illuminated by the narrow beam of his present consciousness. Vignette: a definition of the mind.

Thomas Bewick (1753–1828) worked on a miniature scale, but in his way he is the complete English artist – master of a highly inventive graphic technique, strong on empirical observation, with a vein of fantasy and of comedy too. His woodcut volumes, *A History of Quadrupeds* and *A History of British Birds*, acquired a proverbial character, providing the standard popular image of birds and animals for generations. His vignettes are little spells.

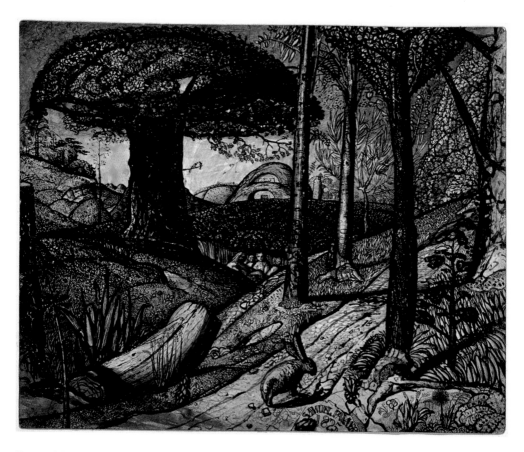

Samuel Palmer, *Early Morning*, 1825
Pen and ink mixed with gum arabic, 18.8 x 23.2 cm
Ashmolean Museum, Oxford

of fields, bathed in sunlight, with darker hills beyond them – ah, that's where we want to go, over there to the bright meadows, will we ever reach them? (In the earlier pictures everything is present, there's no *over there*.) By the age of thirty he had used up his genius and his private money. The brotherhood had disbanded, he'd got married, and went to Italy, and joined the ongoing English landscape tradition. He's never a bad artist. Vividly particular in the 1840s, by the end he might be a soft pre-Raphaelite, with a rainbow-hued palette. He died in 1881.

Palmer is popular, and going round a Palmer show is to see people looking at the pictures, the earlier ones especially, with a special commitment, not just nodding and chatting but properly captured. And of course, looking at someone else enacting a response can't but make you wonder about your own. Are we a bunch of enclosure-seekers, hobbit-minded back-to-the-wombers? Is this bad?

Palmer's great works, because they're so simple, because they do one single thing so strongly, tend to put this thing, and one's enjoyment of it, on the spot. Should we love enclosure? Should we prefer expansion? It's a matter of taste, yes, but it's more than a matter of taste. Enclosure versus expansion: it's a very general psychological, moral and political polarity. It's the sort of point that could determine, not just the art you like, but how you believe life should be lived or society organised.

People always feel that ethics and aesthetics connect somehow. As John Ruskin said ringingly: 'Taste . . . is the ONLY morality. The first, and last, and closest trial question to any living creature is, What do you like? Tell me what you like and I'll tell you who you are.' And if that's sounds implausible, then art like Samuel Palmer's shows how it could be true. Our spatial feelings are so fundamental. Is this the kind of shape, the kind of sensation you like? Are you an expander or an encloser? Are you for mess or for structure? Do you prefer flux or fragmentation, rush or calm? These are big, deep questions that confront us in art and everywhere else. What's your paradise?

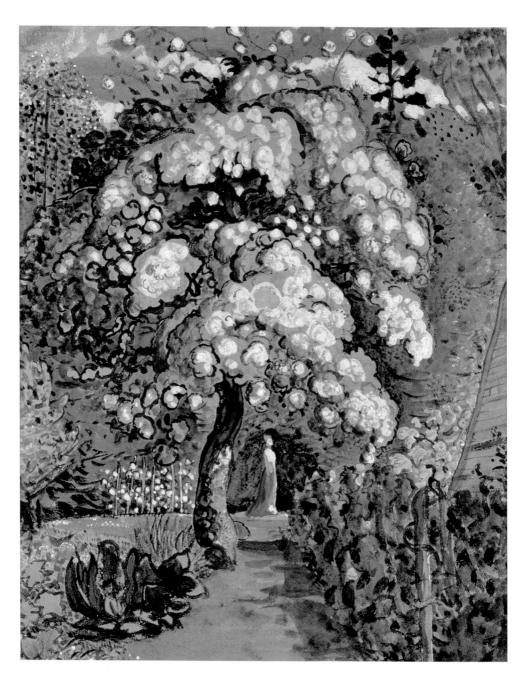

Samuel Palmer, *In a Shoreham Garden*, 1829
Ink and watercolour on board, 27.9 x 22.2 cm
Victoria & Albert Museum, London

IN A SHOREHAM GARDEN

'Visionary' is a word that art critics should try to do without. We use the term with abandon, as if we all knew what 'visionary' experiences were, and could easily spot them when they turned up in a picture. But apart from the fact that it's invariably an expression of praise, the word can mean so many things it tells you nothing.

How does a picture earn the 'visionary' tag? It's not enough to show a supernatural vision. Images of (say) the end of the world, however stupendous, don't qualify as 'visionary' per se. They are just illustrations of Christian mythology. But if an artist (like El Greco) adds weird colours and forms to his supernatural scenes, then that is 'visionary': it's like a hallucination. Or if an artist (like Blake) makes up his own supernatural world, that's 'visionary' too: it all came out of his own head.

But images of the natural world may also qualify, under certain conditions. The scene must be somehow heightened, that's essential. But this heightening must also carry a sense of deep revelation. It must not merely indicate extreme light conditions or optical sensitivity (which possibly disqualifies Turner and Monet). And it must not be just pictorial experimenting (Fauvism isn't 'visionary'). To be 'visionary', the scene must suggest that the spiritual is peeping through the natural world – or at least, that the natural world is seen in a very charged-up state of mind.

Further ambiguities remain. Does a 'visionary' picture have to record an actual vision or hallucination – or is an inner, imaginative vision sufficient? And are there any sure signs of visionariness? Some 'visionary' pictures lose focus, are blurry and apparitional. Some have very sharp focus, a 'hallucinatory clarity'. Some have strong colours all over. Some glimmer out of pitch darkness. Some have excessively orderly compositions. Some are a reeling chaos. The term 'visionary' covers all these possibilities. It can only obscure important differences.

For example, Samuel Palmer's *In a Shoreham Garden* is always called 'visionary'. Obviously, in this case, the term doesn't imply a supernatural scene. This image offers a view of nature. True, it's visually heightened: the colours of nature are keyed up, and the forms of nature are in some ways radically altered.

But before you reach for the 'visionary' label, ask what precisely is going on.

A tree stands in a garden. A path runs past it, directly away from us. At the end of the path a woman in a long red dress passes dreamily across. But she is dominated and upstaged by the tree, which fills the scene, and takes centre position, like someone in a portrait. This simple device makes the tree into an individual creature. It's a crucial effect – probably just as important to the picture as the spectacular metamorphosis that the tree is treated to.

This tree is usually described as an apple-tree. It might as well be a cherry. But either way it is a tree in full blossom – and of course you must recognise that, so as to notice how the blossom has been transformed. It hangs on the branches not so much like blossom as like a shaggy fleece, or bubbling foam, or proliferating fungus growths, or clusters of pearls.

And the fact that all those diverse similes can apply is indicative. Normally the differences between wool and foam and puffballs and pearls are plain enough. It's a matter of their surface textures. But Palmer's image doesn't convey any information about what stuff the blossom is made of. It leaves the question suggestively open. What it tells you about is the blossom's form.

It seems to have congealed. Real blossom consists of bunches of flowers, thousands of separate petals with space between them. But Palmer eliminates any sense of distinct multiple minutiae. It's as if all the particular petals had filled out and fused, becoming a single mass. Not a smooth mass, though: each branch of blossom becomes an amalgam of rounded bobbles rendered in white blobs of paint, and defined by firm cumulus contours, which are sometimes emphasised with bold black outline. The soft frilly matter of the blossom has expanded and coagulated into solid bulbous clumps, or perhaps something more liquid, viscous and fondant.

This perception of nature isn't utterly unfamiliar, either. It's quite common to be taken aback by a tree in full blossom, partly from its shock of pure colour, and partly because the blossoms are so dense and abundant that they do indeed seem like undifferentiated masses. We look and see before us is something that we know isn't quite true, and we're amazed.

Palmer's image takes this normal 'vision', and intensifies it. He makes the blossom absolutely dense. He shapes it into forms that are tight and multi-globular, as if something were bubbling up, or bursting out. And he makes it luminous. It seems lit, not by daylight, but from within.

The blossom becomes a substance that swells and pours and glows, that feels hot, that doesn't merely hang on the bough but emanates and overflows and radiates out, in a slow explosion, from the heart of the tree – a tree that stands before us like a creature with its own identity. Altogether, we're to feel that this vegetable is imbued with inner force, animated with active energy or spirit.

Call this 'visionary', if you wish. It's a distraction, though. 'Visionary' implies: this is somebody's vision. This is how nature would appear to a mind that was spiritually sensitive, or drugged, or mad. In other words, it draws your attention away from the picture itself, and makes you think of some consciousness (the artist) who saw the world this way.

But what the picture asserts is plain: the growing organic world is full of glorious occult power. Rather than call it 'visionary', call it a kind of caricature. It's an affirmative caricature, which – with a little exaggeration – brings out the alleged character of a tree in blossom, as normal caricature brings out the alleged character of a person. Don't shift responsibility for the image on to private visions. Treat it as a public statement about the nature of reality. Then you can ask the question that the word 'visionary' always evades: do you believe it?

Samuel Palmer (1805–81) has been called 'the English van Gogh'. He was an extraordinarily precocious, original artist. In his early twenties, inspired by Blake, Dürer and his own 'primitive and infantine vision', he produced a series of radiant rural scenes. He founded the first British avant-garde, the Ancients. He reacted to the modern world with medievalist Romanticism: 'The past is for poets. The present for pigs.' When his works were rediscovered in the 1920s they influenced every British Modernist.

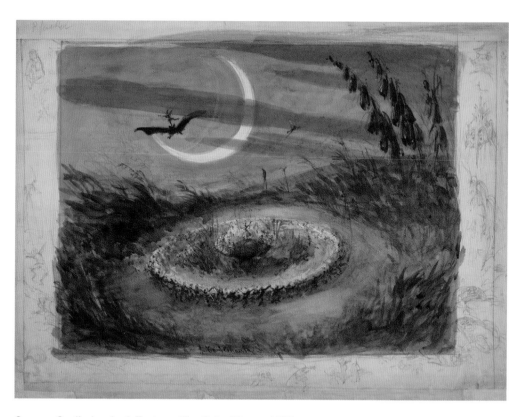

George Cruikshank, *A Fantasy: The Fairy Ring*, c.1850
Watercolour with graphite and bodycolour on paper, 37.1 x 49.8 cm
British Museum, London

A FANTASY: THE FAIRY RING

The fairies? It sounds a bit like this. T. S. Eliot imagines the figures in his poem, 'East Coker', in a country setting, remote and haunted.

> In that open field
> If you do not come too close, if you do not come too close,
> On a summer midnight, you can hear the music
> Of the weak pipe and the little drum
> And see them dancing around the bonfire
> . . . Round and round the fire
> Leaping through the flames, or joined in circles,
> Rustically solemn or in rustic laughter . . .

These words certainly cast up a midsummer mood. But they don't need to convey any magic realm. A folk ritual could be all it suggests. And then there are the twee little creatures, butterfly-winged and smiley, conjured up in many Victorian paintings; or indeed in the affair of the Cottingley Fairies, faked photographs produced in 1917 by two young girls, and taken up in quasi-scientific psychical research by Sir Arthur Conan Doyle.

But there are also images where you can find wilder and darker fairies. For instance, look at George Cruikshank's *A Fantasy: The Fairy Ring*. Here, within the pencilled margin of drawn frogs and goblins, his vision is sketched out. And whatever his real belief may be, this illustrator shows a truly mysterious experience, imagining something excitingly extra-sensory.

It is growing dusk on the crest of a hill. The evening sky is spooky and the ground is at a deep slant. Nodding foxgloves stand to one side. Dark grasses are combed around a centre. There is a bat flying at an angle, and a little hopping elf is on his back, while smaller elves are visible too. This is the spot where we find the magical ring set on the earth.

The airs are gathering. Clouds are dashing across the sky. And above the ridge of the land is a large crescent moon, almost as new as can be. It makes an echo between sky and earth – that is, between the round edge of the moon and

the round edge of the fairy ring where the action is right in the middle of the dance.

There is a ring within a ring. At its heart is the fairy queen, while in the outer ring, creatures are thrown around and about. They are like seeds or black miniatures flung criss-cross in whirling, running motion. The spinners rotate and turn on a counter-clockwise 'widdershins' hub. The energy of the ring creates a glow and a hum and a blur and it goes so quickly and so roundly that it cuts an empty clearing in the grass, like a tonsure in the ground.

It is an extreme fairy world. Our view looks right down on to it. We are very far from being amongst them and we have no inclination to identify with them. On the contrary, these creatures are in their alien element and we cannot inhabit their existence. Their lives are weird, hard to grasp, beyond our touch or sight – below our perception and beneath our sensory threshold.

The wild fairy world, as imagined here, could be compared to the sub-perceptual world of bats. Spinning fairies and flying bats coexist in Cruikshank's fairy fantasy. Its soundtrack might be this extraordinary poem by Les Murray called 'Bats' Ultrasound' – 'Where they flutter at evening's a queer / tonal hunting zone above highest C.' The final verse is almost impossible to read as words on the page. But if you read them aloud, their spell will carry into the air.

Ah, eyrie-ire; aero hour, eh?
O'er our ur-area (our era aye
ere your raw row) we air our array
 err, yaw, row wry – aura our orrery,
our eerie ü our ray, our arrow.

A rare ear, our aery Yahweh.

George Cruikshank (1792–1878) was an English caricaturist and illustrator. Very popular in his lifetime, he came to supplant Gillray in the English imagination. Known for his violently patriotic and racist images, portraying the Irish as apes, he was the illustrator of Dickens, and they only fell out when Cruikshank became a fanatical teetotaler. In 1860–62 he made his gigantic temperance painting of a debauched London, *The Worship of Bacchus*.

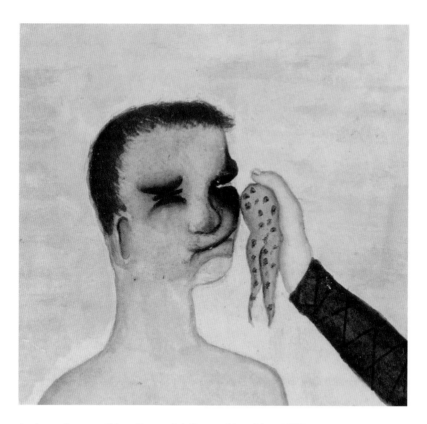

Artist unknown, *West Bromwich Sweep* (detail), *c*.1850
Watercolour, 48.5 x 60.3 cm
Compton Verney, Warwickshire

WEST BROMWICH SWEEP

There's nothing to beat seeing a man being beaten to a pulp. Before boxing gloves were introduced by the Queensberry Rules of 1867, bare-knuckle fighting could cause extreme facial damage. And it is clear from images and written accounts that the mess was part of the fun. For instance, in Thomas Rowlandson's *Six Stages of Marring a Face* – a cartoon-strip, depicting step-by-step the wreckage of a boxer's features. No opponent is shown. All attention is on the spectacle of progressive and bloody rearrangement.

William Hazlitt wrote a horrible little essay called *The Fight* in 1822, in which he describes how he and other lovers of 'the FANCY' take an excursion out of London to watch a big match between William Neate and The Gas-man (as he's nicknamed). Hazlitt coos and twitters at the prospect, and then at the sight, of two fellows smashing each other to bits. He tosses in literary quotations and classical allusions. He thrills self-consciously at the crudely violent but yet magnificent manliness of it all. He relishes the chance to exercise his powers of description, as the Gas-man gets the worst of it.

The Gas-man aimed 'a mortal blow at his adversary's neck'. But Neate 're-turned it with his left at full swing, planted a tremendous blow on his cheek-bone and eyebrow, and made a red ruin of that side of his face. The Gas-man went down . . . all one side of his face was perfect scarlet, and his right eye was closed in dingy blackness.' The fight continues. And 'to see two men smashed to the ground, smeared with gore, stunned, senseless, the breath beaten out of their bodies; and then, before you recover from the shock, to see them rise up with new strength and courage . . . – this is the high and heroic state of man!'

But at last the Gas-man falls. 'I never saw anything more terrific than his aspect just before he fell. All traces of life, of natural expression, were gone from him. His face was like a human skull, a death's head, spouting blood. The eyes were filled with blood, the nose streamed with blood, the mouth gaped blood. He was not like an actual man, but like a preternatural, spectral appearance, or like one of the figures in Dante's *Inferno*.' Blood, blood, blood, blood, Dante. It is not this great English writer's finest hour.

Sometimes one piece of work can repair, make up for, the damage done by another. And if there is a work that makes up for the frivolous sadism of *The Fight*, it's a picture by an anonymous English folk artist entitled *West Bromwich Sweep*. Hazlitt's writing is fixated on the spectacle of violence. The picture imagines what it feels like. Its overall technique is pretty rough. Its evocation of pain is overwhelming.

'WEST BROMWICH SWEEP As he appeared at george Holdens after his fight with fred higgit being waited on by Jem Parker through wose superior Generalship he won his Battle in 1 hour and 26 mineets on the 7 January 1850', reads the semi-literate caption. This is a detail, and if you look in the original at the pictures hanging on the wall of the pub, either side of the strangely beautiful candleholder, you can see how the Fancy was normally portrayed: the man posed, ready before the fight, dukes up, showing his brisket. But here we see the aftermath, the tending of wounds. And it's in the depiction of the boxer's head that this image shocks, and exceeds all expectation.

It's not the Sweep's heavy bruising and swelling as such that the picture stresses – it's his searing pain, extreme tenderness, sensory confusion and general pitifulness. His head is inflated, too big for his body (the other figures' heads are all in scale). Its sensations become larger than anyone else's in the room. It also becomes baby-like, helpless. And the head-body joint is not properly articulated at the jaw. The head simply grows out of the neck, it is itself a swelling, a ballooning lump of flesh without self-control; helpless again.

Or look at the features. There's the right eye, 'closed in dingy darkness', formed like a black butterfly. The shape represents its contusion, but this symmetrical graphic sign also feels like it's stamped on to the face. The eye has been simply obliterated, turned into this blind and meaningless mark. And there's the left eye, bruised and blackened, and depicted as a negative shape, cut into the edge of the face like a slot.

The bruising of the cheek is made of pure blackness that stains or corrodes into the side of the face from the edge. And the extreme tenderness of this cheek is conveyed by the extreme gentleness of the flannel that is dabbing against it.

PORTRAIT OF HIMSELF IN BED

Take a blank white sheet of paper. It depicts nothing. Look at it hard. With the best will in the world, can you see anything in it? Well, you can try. In the 1880s the French humorist Alphonse Allais proposed an entirely white picture which would be entitled *Anaemic Girls Going to Their First Communion in a Snowstorm*.

Following that title, you could gaze at your blank sheet and attempt to see, not an unmarked surface, but an image – an image of a pure and uniformly white world. But it would be hard to hold on to this perception. Very quickly the page would reassert its blank self.

Once you start drawing lines on it though, everything changes. Suppose you enclose an area with a random outline. Even though it's not the outline of anything in particular, the white paper within this enclosure is already no longer blank: it becomes full, it becomes a substance of some kind, the *contents* of the outline that surrounds it.

And if you draw the outline of a human figure, and draw it very sensitively, the white paper within the outline, though still quite empty itself, will be filled with implied information. You look at it and see in it rounded flesh and musculature, flowing and folding drapery.

Aubrey Beardsley is a master of the economical but richly implicative outline. With only a finely traced edge he can conjure the whole substance of a figure – its firmly and tangibly swelling belly, its loosely sagging pantaloons. This outline-virtuosity is a basic element of his draughtsmanship. He delivers it so effortlessly that he can also confidently play around with it.

Often he undermines articulate outline with another, opposite effect – a negative device, which puts his depictive powers into reverse. At a crucial point in a drawing he makes the white paper go blank again. Where you expected a white area to be filled with implied information, suddenly it becomes unreadable, mere empty page.

The *Portrait of Himself in Bed* is a startling image in many ways. Hardly anyone is ever portrayed in bed, let alone self-portrayed. (The convention is mainly used for corpses: the death-bed portrait.) What's more, the artist depicts

himself as a tiny figure. It's a self-portrait where you have to spot the subject, half-hidden, turbaned, drowned in the bedclothes of an enormous curtained bed.

The richly tasselled and embroidered drapes hang down from a high 'crown'. The visible bedpost is carved with the form of a bare-breasted female satyr. The French inscription in the corner is an untraced, probably made-up 'quotation': 'By the twin gods, not all the monsters are in Africa' – which sounds like it might come from some decadent author, and casts the bed-bound artist as a dreadful monster of depravity. (What's he up to, under the sheets?) The engulfing bed is a bed of indolence, debility and voluptuousness – a typical decadent 1890s blend. The artist is in every sense a sick man.

His figure is literally folded into the bed, pressed like a flower between the enveloping origami layers of the scene. His little face peeps out between spotted turban and frilled nightshirt. He is inlaid between sheet and pillow. Finally he is overlapped by the great swag of black curtain. This is not a figure in bed, distinct from the bed it's in. It's a figure whose body is lost in a world of soft furnishings. He is tucked into the bed, and into the image, like a bookmark, a slip of paper.

The whole scene tends to go paper-flat. Its outlines may seem very sensitive and informative, but Beardsley never shows quite *enough* of the outline of anything to establish clearly its three-dimensional form. In the architecture of the bed, each element – the billowing drapes, the plump bedding – is cut off by something else or cropped by the frame. We only see partial segments of these things, and can't deduce from their visible edges precisely how they would occupy space – how they billow, how they plump out. And when we dwell on these shapes they are liable to revert to being flat areas of black or white.

This happens most dramatically with the largest area of white in the picture. It's the area that represents (presumably) the extravagantly folded-over top sheet. Its solid form never properly materialises. Its sides are wholly overlapped by the black curtains. And the outlines that define its top and bottom boundaries, though they indicate something voluminous and eiderdowny, don't give us a clue about how its volumes – its mountains and its valleys – would body out.

When you look at this white area, you lose your depictive bearings. It doesn't take form. It goes empty – a blank, inarticulate void, an expanse of whiteness, into which nothing definite can be read, and into which the body of the artist disappears. His bed-sheet is the sheet of paper itself.

Aubrey Beardsley (1872–98) had the shortest life of any major artist. The sense of hurry is real. From his late teens he was coughing up blood – he had good cause to expect an early death and to perfect his art fast. He crammed his development, bolted influences. From a starting point of schoolboy cartooning, and largely self-taught, he picked up elements from the pre-Raphaelites and Greek pots, Japanese prints and Rococo ornament, and forged them into the most distinct, pure, black-and-white graphic style of modern times, ideal for line-block reproduction. He illustrated Oscar Wilde, *The Yellow Book* and other aesthete publications. He filled his drawings with opulence, perverse innuendo, the grotesque, exquisite delicacy and explicit obscenity. The principal British representative of Art Nouveau, his impact was Europe-wide.

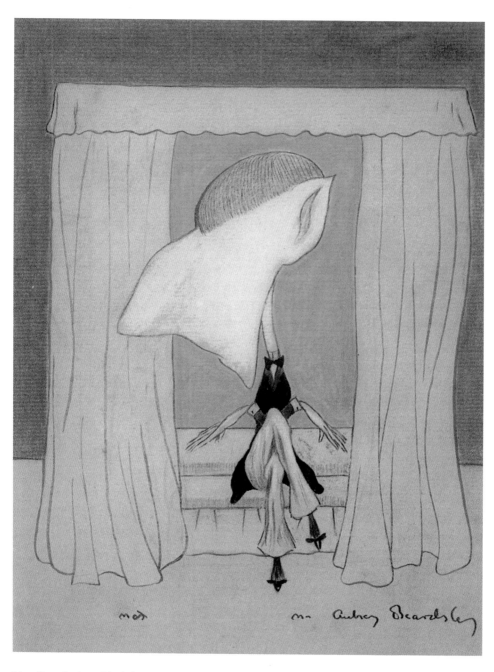

Max Beerbohm, *Mr Aubrey Beardsley*, from *Caricatures of Twenty-five Gentlemen*, 1896

MR AUBREY BEARDSLEY

Wittgenstein was talking about how philosophers are led into fruitless perplexity. They ask questions that *sound* like sensible, answerable questions, but turn out not to be. He offered this analogy. 'Philosophers often behave like little children who scribble some marks on a piece of paper at random and then ask the grown-up "what's that?" It happened like this: the grown-up had drawn pictures for the child several times and said: "this is a man", "this is a house", etc. And then the child makes some marks too and asks: what's *this* then?'

But never mind about philosophers and little children. What Wittgenstein describes is something that grown-up artists do, and to good effect. It happens like this. The artist builds up an image out of an array of marks, and each of these marks stands for something. But then the code breaks down. The picture contains some marks – not necessarily scribbles – that can't be properly deciphered. They ought to stand for something. You can actually see the representational function they should be performing. But when your eye asks 'what's *this* then?' there is no definite answer. The marks won't read.

This unreadability needn't produce just bafflement. It can be powerfully expressive. One thing it can express, for instance, is a sense of violation. Looking at Goya's massacre-painting, *The Third of May*, where the face of a dead man is an unreadable mess of paint, Robert Hughes observes: 'The wounds that disfigure the face of the man on the ground can't be deciphered fully as wounds, but as signs of trauma embodied in paint they are inexpressibly shocking: their imprecision conveys the sense of something too painful to look at, of the aversion of one's own eyes.'

You can't bear to look? That would be one way to understand Goya's failure to depict. But equally it could convey that this face is utterly wiped out, outraged, ruined beyond recognition, defaced – the breakdown of depiction miming the extremity of the damage inflicted. Either way, the very meaninglessness of the strokes acquires a sense, a negative sense. It communicates some kind of loss. The effect is not necessarily horrible, though. In Matisse's drawings, the women's outlines often drift off – for a stretch – into a watery undulation. They carry no anatomical information, but they convey a body losing itself in a blissful swoon.

Or again, unreadability can be used to suggest terminal helplessness.

The youthful caricatures of Max Beerbohm have a merciless eye for weakness. Most people's caricature is a vivid and even monstrous assertion of its subject. It injects energy or vigour into the personality. But what makes Beerbohm's so intimately lethal is that it touches the spot where personality fails. His victims were almost always known to him personally. His cruelty was to inflict pathos, to insinuate a note of debility. The feeling enters into the drawing itself. Somewhere the line stops being descriptive, wanders off its subject, trails away.

Beerbohm captured the illustrator Aubrey Beardsley several times. They were exact contemporaries. The last picture – made two years before Beardsley died of consumption aged twenty-six – is the most extreme. It shows him as a meagre, dainty, hyper-sensitive figure, limp-wristed and twinkle-toed, with an elfin ear and a monkish fringe that totally obscures his vision. The head as a whole is one of Beerbohm's freest manipulations, distorted almost beyond sense. The face-in-profile is like a fluttering hanky.

There's one particular point where recognition stalls. See what happens between the tip of the nose and the tip of the chin. Both of these points are sharply stressed. But along the outline between them, all angles and information are abolished. This whole stretch of profile – the under-nose, the upper-lip, the mouth, the under-lip, the front of the chin – is reduced to a single gently wavy line.

In Beerbohm's previous caricatures, Beardsley has a rather Easter Island profile, the coastline between nose and chin presented as a succession of sharply jutting shelves. But in this version it becomes a shallow tremor. The bridge of the protrusive nose is still well defined. But beneath it, the lower face prolapses. Description fails, and leaves an evacuated area, a flaccid wobble. You can see what it's meant to represent – but follow this contour along, seeking the expected features, and the signal has become hopelessly faint, as if the life of the face was ebbing away.

This is felt most keenly at the mouth. A mouth is always a touchy spot. But in this picture it's barely there, a non-mouth or not-quite-mouth, indicated by a mere gap, a slight break with a slight overlap in this feeble undulation. You can't

say what the set of this mouth is, whether it's open or shut. It's rendered in a way that's indecipherable. The just-not-touching, just-overlapping opening creates a frustrating vagueness. You want the gap to close, the lines to meet, to form something clear and readable, to define a nice prim little mouth. But they won't.

It is a fearful defacement – and all the more so because you can see it, not as something done to the figure, but as something the figure is doing itself. This failure of facial definition is in character. It fits in with the personality of Beardsley, as established by the rest of the caricature. Its inarticulacy looks like an aspect of the figure's own exquisite refinement and sensitivity, a further expression of the fastidious tentativeness so evident already in its body language.

In other words, Beerbohm implies, this is exactly the kind of profile that this dandyish aesthete would make for himself. This is his own ideal face. The standard cut-and-thrust of nose and lips – my dear! nothing so crude, so vulgar, so physical. The face's ins and outs are to be registered as a barely fluid motion, a flicker, the merest nuance, something barely indefinable; physiognomy as *je ne sais quoi*. Caricature doesn't get more insidious, more inside.

Max Beerbohm, (1872–1956) was an essayist, parodist, critic, cartoonist, and man-about-town. His literary parodies are simply the best ever. As a cartoonist he was an amateur of genius. He borrowed the style of the Victorian *Vanity Fair* caricaturists, with their sharp sense of pose and social presence, and infused it with the flaccid helplessness of Edward Lear's nonsense drawings. He specialised in his great contemporaries in art and letters, who were also his own social circle. He knew them inside out, and they knew it. When Henry James, one of his favourite subjects, was asked his opinion on something at a dinner party, he pointed across the table to Beerbohm: 'Ask that young man, he is in full possession of my innermost thoughts.'

This side up.

PORTRAIT OF ITS IMMANENCE THE ABSOLUTE.

Instructions for Use.—Turn the eye of faith, fondly but firmly, on the centre of the page, wink the other, and gaze fixedly until you see It.

SOWER OF THE SYSTEMS

In 1901 some feisty young English philosophers put out a parody-issue of the philosophical journal, *Mind*. They called it *Mind!* Their target was 'idealist' Hegelian philosophy, then dominant in Oxford University.

The first page of *Mind!* had an image with a rectangular border. Above the image were the words 'This side up.' Beneath the image were the words 'Portrait of Its Immanence the Absolute'. It was, in other words, a supposed depiction of the ultimate principle of reality. You may have guessed that within the border there was nothing but empty white paper.

To make the joke clear, it had a caption. '*Instructions for Use.* – Turn the eye of faith, fondly but firmly, on the centre of this page, wink the other, and stare fixedly until you see It.' A belief in the Absolute is being equated with one of those optical illusions of which the Victorians were so fond – or with an act of self-hypnosis. Moral: there is really nothing there. But another way of looking at this joke would be to say that the authors of *Mind!* had invented one of the earliest examples of abstract art, or perhaps conceptual art.

It isn't art, not really. It's not even a joke about art. But the *Mind!* blank page is clearly connected to one of the central jobs and problems of European art: representing God.

It wasn't always a problem. Medieval and Renaissance artists knew what to do. Despite the strictures of mystics like Meister Eckhart, who deprecated those who 'want to see God with the same eyes with which they behold a cow', the solid old man with the beard went on being an acceptable image for a long time.

Then qualms began. In 1802, John Flaxman did a set of line illustrations to Dante's *Divine Comedy*. In the last one, where he had to show the divine presence at the centre of the universe, Flaxman baulked. He drew some concentric radiances, and in the middle left a white space – with the very faintest outline of a human head and shoulders in it.

It's an early anticipation of the negative solution: the idea that, when it comes to depicting the ultimate, the infinite, the be-all and end-all of the universe, all a picture can do is go blank. The subject is invisible, or more than invisible, simply beyond representation just as it's beyond human comprehension.

G.F. Watts, Study of the figure for *Sower of the Systems, c.*1898–1903
Pen and ink on paper, 12.7 x 10.1 cm
Watts Gallery, Compton, Surrey

By the early twentieth century it wasn't unusual for the new abstract art to see itself as a picture of the unpicturable. In 1920 Kazimir Malevich described his *Black Square* as a kind of anti-icon: 'I had an idea that . . . perhaps the black square is the image of God as the essence of his perfection . . .'.

And what of George Frederic Watts? Just a year after *Mind!*, he painted *Sower of the Systems*. You couldn't really call it a great work. It's a messy, clumsy work. But it's an extraordinary work too. Made before the era of abstract painting, it teeters on the brink of non-depiction. It shows a blue-robed figure, striding away from us, its head hidden in the fiery arcs of space, its arms casting golden comets about it. But the whole image is dissolving into sparking and swirling cosmic chaos.

Watts made a pen and ink thumbnail sketch for the figure that gives us a bit more idea of its structure. Not very much. It's a sort of gas cloud with legs, a figure robed in a vortex of scribbles. If this is God, creating the universe, then it's not like the creator as normally imagined and depicted by Christianity – a creator separate from his creation, who calls it into being and gives it shape from outside; a creator who gets the whole job done in one seven-day go. Watts was a keen star-gazer. The divine presence seems to be thoroughly involved and whirled about in the cosmos he's making, to be one more cosmic force among a whole lot of other forces. And the dynamic, spiralling lines suggest that creation is not a one-off but a continuous process, and perhaps a simultaneous process of creation and destruction.

Or to put it another way, it's all a blur. God is a blur and the universe around God is a blur. It's a picture that says: I believe in something, I don't really know what. Watts' divinity is an unsatisfactorily vague and anonymous figure. He said his visual inspiration was the play of a night-light on the ceiling. His God is a mere glimmering.

Sower of the Systems stops at a halfway solution. It hovers between figuration and abstraction – between the definitely embodied and bearded God of traditional iconography, and the utter beyondness of *Its Immanence the Absolute* or *Black Square*.

Watts knew it wasn't quite right. He had an inkling of the way it ought to be done. He said: 'My attempts at giving utterance and form to my ideas, are like the child's design, who being asked by his little sister to draw God, made a great number of circular scribbles, and putting his paper on a soft surface, struck his pencil through the centre, making a great void. This is utterly absurd as a picture, but there is a greater idea in it than in Michael Angelo's old man with a white beard.'

In his own work, Watts stopped at circular scribbles – *Sower of the Systems* is full of them. But he saw ahead, beyond abstraction, beyond blankness even, to the ultimate step: the hole, the void. It took another fifty years for someone not to think it absurd.

'If I have made an important discovery, it is without doubt the hole . . . The hole was completely outside the dimension of the picture – it conferred the freedom to reconceive art.' This is the Argentinian-Italian artist, Lucio Fontana, famous for puncturing and slashing the canvas. He spoke of pursuing 'the infinite, the inconceivable chaos, the end of figuration, nothingness'. His great work is a series of egg-shaped canvasses, peppered with holes. They're entitled *The End of God.*

G.F.Watts (1817–1904) is one of the heroic failures of British art. He was enormously ambitious and high-minded. He should have been a kind of visual Wagner. He painted an inspirational hall of fame, with ideal portraits of the great Victorians. He specialised in grand symbolic and transcendental subjects – *The Dweller in the Innermost*, *She Shall be Called Woman*, *The All-Pervading*, *Sower of the Systems* – images which suggest William Blake, dipped in cake mix. All that is visible now is the unequal struggle between a desire to conjure mysteries and a very limited technical competence. His grotesque, weirdly Modernist equestrian statue, *Physical Energy*, still charges through Kensington Garden in London.

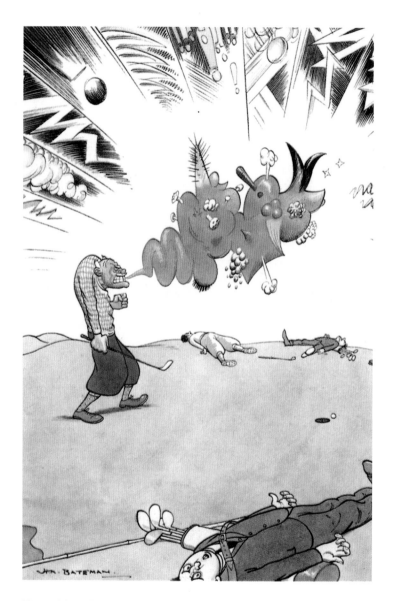

Henry Mayo Bateman, *The New Word in Golf*, *c.*1925
Watercolour, pen and ink on paper
Private collection

THE NEW WORD IN GOLF

Glenn Gould, the great pianist, had a suggestion about Modernist music. Although apparently rejected by the ears of the general public, it could be made more widely acceptable; in fact this was happening already.

'I think that there is little doubt that there are some areas in which the vocabulary of atonality has made quite an unobjectionable contribution to contemporary life . . . If you really stop to listen to the music accompanying most of the grade-B horror movies that are coming out of Hollywood these days [1964], or perhaps a TV show on space travel for children, you would be amazed at the amount of integration which the various idioms of atonality have undergone in these media.'

A taste for 'squeaky door' and 'plinky plonk' music (as the nicknames go) was being popularised through the background themes of horror and sci-fi. The highest art was being spread via the lowest genres. Gould merely regretted that, so far, the public found modern music 'satisfactory only for displaying the fundamental beastliness of the human animal.' But this could change.

And what about other art forms? Tate Modern has done good work, and modern visual art was never as unpopular as modern music. Still, perhaps here too low genres have helped to familiarise the difficult avant-garde. Cartoons?

H. M. Bateman, the cartoonist who invented the 'The Man Who . . .' cartoons, was a man who had no time for modern art. He occasionally drew cartoons about it. He mocked, and his mockery was not especially bitter. Still, he might be surprised to learn how far, in one picture at least, it had got into him. (This idea develops an observation of George Melly.)

We are on the green. Our man has just missed the easiest putt in the world. The ball sits insolently on the edge of the hole. Scattered around him, knocked flat, his caddy and fellow golfers lie. Out of his mouth comes a shattering expletive, *The New Word in Golf.*

It goes off like a bomb. The sky radiates with its blast, in an explosive array of fanning lines of force that reverberate with zig-zags and zooms. Cartoon tricks? No, they clearly show traces of modern art. These dynamic forms are borrowed from Futurism and Vorticism. Lately, advanced artists had used them to express

the energy of new technology, the destruction of the Great War. Now they are on the golf course.

But despite this surrounding blast, the expletive itself is not being yelled out of an open mouth. It's being squeezed, extruded, through clenched teeth, from a face and body fully screwed up. It is literally expressed, to emerge as a raw, red-hot, pustular, intestinal, ectoplasmic blob, shuddering in the air.

What does this blob signify? It seems obvious, until you try to say. It could be an inventive form of euphemism, an expletive deleted in fact – deleted by this blob. We see a visual substitute for an unspeakable verbal obscenity that a polite publication can't print. Or it could be that the blob gives an embodiment to a curse that transcends existing language. We have to imagine a rage so terrible it needs a swear word that has never been used before.

A paradox: an obscenity can't be coined. A truly new swear word is impossible. You can have an unprecedented roar, but swear words, even (or especially) the worst, must be known to have any effect; there is a list of them. And it's part of the power of this *New Word* that its designation baffles us. We don't know whether it stands for just a *very* rude word, or a horribly ugly noise, or a fury so awful it can't be given voice at all, or some kind of unknown metaphysical expletive.

Whatever, its character is clear enough. It is the essence of all wrath. It steams, it froths, it foams, it bristles, it boils and bubbles over, it's covered with verbal metaphors, all meaning anger (though the toadstools are more obscure). It throbs with the sores and bruises of wounded feelings. It vents with farting lips. It's impaled by a truncheon exclamation mark. But take away all those excrescences, and what have you? A curvaceous, semi-abstract form.

It seems that in this extremely expressive and mimetic shape Bateman has again drawn inspiration, and more deeply, from Modernist painting or sculpture. This form has a gross and fleshly turn, suggesting both the outsides and the insides of a body, with echoes of Miró or Arp, Surrealism generally, and even Francis Bacon. Just as the 'screeching' music of Schoenberg or Webern makes a suitable soundtrack for horror and sci-fi, so the 'monstrosities' of modern art

have furnished this cartoon with an amazingly graphic expletive, expressing 'the fundamental beastliness of the human animal' on the golf course.

But one difference from the musical examples, and an odd thing, is that Bateman's creation actually predates most of the artworks it seems to be inspired by. (Modern art: the first time as farce . . .) Though its year is uncertain, it must be around 1920. It anticipates pretty accurately those post-Second World War sculptures that acquired the nickname, 'the turd in the plaza'. Take Bateman's *The New Word in Golf*, reduce it to its essential contours, cast it in bronze, and the resulting object would be entirely at home in the centre of a new town. You could call it simply *The New Word*.

Henry Mayo Bateman (1887–1970) began his 'The Man Who . . .' series in 1912 but it was his work for *Tatler* in the 1920s, when they appeared as colour spreads, that made his name and earned him a great deal of money. So successful was he, unfortunately, that he retired in his mid-forties to concentrate on his painting. Bateman's eye was on suburbia and all its petty embarrassments: around sport, etiquette, money, convention, and as he grew richer, smart hotels, class and the social calendar. He developed elegant, economical strip cartoons in black and white extending over several pages. Master of the sweating subordinate, Bateman's sympathy was with the underdog.

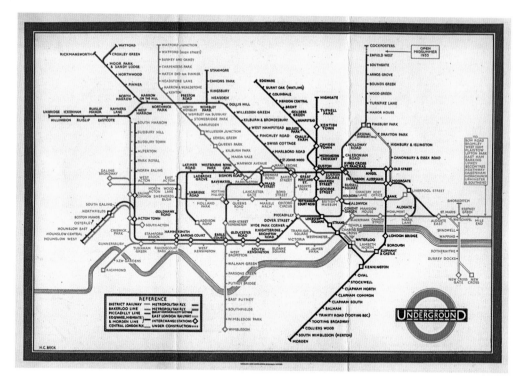

Harry Beck, *The London Underground Map*, 1933
London Transport Museum Collection

THE LONDON UNDERGROUND MAP

Some maps look like images, not by trying, but simply because some lands look like figures. Great Britain, for example, resembles an approximate figure: Scotland the head, East Anglia the bottom, Wales the hands, the West Country an extended leg. Some very old maps can look like caricatures. It's as if they had taken a country's profile and pulled it out of shape, giving it a grim or cheerful character. Some maps, though, have very little relation to geography. Think of the London Underground map.

Other cities show you the facts. In Paris, at any station, you can find a layout of the Metro's lines, a dense and irregular web, superimposed accurately on to a street map of the city. The London Tube map left earthly reality behind long ago. In the early 1930s Harry Beck introduced his revolutionary design.

Beck's great innovation is that his map is not a map. It's a plan or diagram. Using geometrical forms, it displays the lines, the sequence of stations, their connections, in as transparent a way as possible. Tunnels go straight. They lie horizontally, vertically or at forty-five degrees. They bend in regular curves. Stations are placed at regular intervals. Beck's plan observes topology, paying only a minimal respect to geography.

It's a model of clarity for Tube journey planning. It can be very misleading for judging true distances or making walks. The Beck diagram makes the London Underground into a parallel dimension. Its stations become mysterious portals between this self-contained system and the real world above. Few travellers have any idea of where its actual routes run beneath the city streets. All we know is this beautiful fiction. Should we call it a work of art?

It obviously has an aesthetic. Its geometrical forms are a Modernist idiom, conveying Modernist values: functionality, efficiency, economy. It looks a bit like a Mondrian abstract, or like an electric circuit board. (Circuitry wasn't in fact Beck's inspiration, as is sometimes thought, but the likeness is clear enough.) And this visual language doesn't only present the plan's information very efficiently. It suggests that the Tube itself is a very efficient system, a utopia for the

London traveller. Beck's diagram is not a caricature of what it describes, but the opposite: an idealisation.

That's a general effect. But the peculiarity of the Beck plan is that it offers its maker considerable freedom of operation. A proper map allows little liberty. The mapper must trace the world obediently. The Beck scheme has its rules for translating tunnels into lines, but their application is flexible. A bend can happen here or there. Lines may be level or diagonal, parallel or symmetrical. It leaves many choices open, both in its overall formation and in details.

So questions of design arise. What guides these choices? Did Beck arrange his plan with any patterns or figures in his mind? When he has an option about how lines go, does he ever decide by artistic critera? Balance, energy, tension, grace, depiction even? In short, is he drawing with his stout coloured lines? Is he composing?

His graphic decisions may only be guided by clarity, and if we see a composition in his diagram, it may be something we fancy, like a constellation in the stars. True. But then Beck himself may be susceptible to these fancies. It may simply be impossible for him to avoid some form of art.

Perhaps it's too much to suppose he consciously shaped the likeness of a 'hippocampus' – that is Neptune's mythical merhorse – that seems to ride out over the wavy Thames on the west side of the plan. (Its head ending at Uxbridge, its bending legs at Hownslow West and Richmond, its fishtail descending to Wimbledon.) But it's hard to believe he was wholly blind to the abstract forces he was playing with. The five parallel diagonals going across the top are a gratuitous, unignorably dynamic feature.

This is the odd aspect of Beck's London Underground map. It can perform its function, the clear presentation of information about Tube routes and at the same time it can take off into free, creative shaping. Or rather, this combination is odd for a map. It's perfectly normal for a pot or a chair, for a piece of craft, where utility and play are expected to coexist. And with his revolutionary design Beck invented, no doubt accidentally, not only a new form of map-making (which can be used for any similar transport system), but a new form of two-dimensional craft.

Harry Beck (1902–74): another story of British genius under-recognised. He was an engineering draughtsman employed by London Underground when he began to work, in his spare time, on a redesign of the Tube map. His first proposal in 1931 was rejected, but when issued experimentally it proved popular and was adopted. Much of Beck's later life was devoted to refining the design, and trying to keep control over it. The map went through many versions, by him and others. Beck left London Underground after the war and taught at the London College of Printing. His last design to be used was in 1960. Today Beck's name is recognised and the map has returned to something near to his original model.

Percy Wyndham Lewis, *Red Figures Carrying Babies and Visiting Graves*, 1951
Pen and coloured inks, watercolour, gouache on paper, 33 x 40.3 cm
Private collection

RED FIGURES CARRYING BABIES AND VISITING GRAVES

In the spring of 1951, Wyndham Lewis announced that he had gone blind. For five years he had been working as an art critic for *The Listener* magazine, and felt that his readers should know of this development. His increasingly blurry sense of the world had been diagnosed. 'What, in brief, is my problem, is that the optic nerves, at their chiasma, or crossing, are pressed upon by something with the pleasing name of cranial pharyngeoma.' He was now almost completely sightless. Finally he came to the point: 'My articles on contemporary art exhibitions necessarily end, for I can no longer see a picture.' He was nearly seventy. The tumour would kill him six years later. His career as an artist necessarily ended at around the same time.

Of course there have been deaf composers. There have been plenty of blind writers, and for the remainder of his life Lewis himself kept up his literary output, as a novelist and polemicist. There have even been blind art-critics – OK, fair enough, I mean there have been *literally* blind art-critics. The sixteenth-century critic Giovanni Paolo Lomazzo wrote his influential treatise on art after he'd lost his sight, with all the examples taken from memory. He had previously been a painter. There is no case of a fully blind artist whose work is worth looking at, but Lewis comes as near as any.

There's one last picture, a drawing dated 1951. It's a strange valedictory image called *Red Figures Carrying Babies and Visiting Graves*. A row of four or perhaps five indeterminate figures alternate with equally vertical white gravestones. Each figure carries a littler figure. It's a meeting of the newborn and the dead.

One can well believe it's a picture by someone whose central vision had gone, who had to peer at the world in fragments through a magnifying glass. It doesn't look like the work of any other modern artist. It doesn't look much like other works by Lewis. But it has that hybrid quality which makes him such a maverick among Modernists: a scene that's part abstract, part otherworldly vision, part contemporary social comment.

Lewis himself used to moan that the most radical stylistic experiments were performed on the most conventional subject matter. Cubism stuck mainly to

still-lives, nudes, portraits. His essential aperçu was that Cubism could have content: its deconstructed bodies and dissolving spaces could be taken, not as a formal language, but as a strangely living world.

Lewis was not quite a proper modern artist. He was too much of a mixture. Though his abilities as a shape-maker, an abstract designer, are very strong, he doesn't believe in the self-sufficient image. Other things are always getting in. He can't help creating worlds and characters. Even while the figures and settings are semi-abstract constructions of interlocked shapes, they can't help inspiring fictional questions – who are these figures? Where are they? What's going on? As in *Red Figures Carrying Babies and Visiting Graves*.

The queue of figures, are they soldiers or nannies in uniform? They look like stiff infantrymen on parade, probably French. You see their decorations, caps and medals. They are columnar, stacked creations, each one a mournful totem. And the babies! Each soldier carries a child, not cradled, but held like a wreath. The difference between the bodies of the soldiers and the bodies of the babies is terrible. The soldiers have tunics and trimmings to bulk them. The babies are in another register; crude waifs of wiry line. Behind them rises the clipped green lawn of the war cemetery. Behind that there is an odd opening, a doorway, an entrance? Distinct identities fail. Everywhere there are little vanishing acts.

As it is Lewis, nothing is straightforward. But even at this late stage his pictures have a strong visual impact – in the contained force of their shapes, their still delicious colours (where else but in Lewis do you find such yellows, such pinks?), their extraordinary elusive textures that mix sharp separation and dissolving fusion, two-dimension and three-dimension, opaque and transparent. The transition from abstraction to figuration is never a problem for him because his shapes are creatures already.

In the late 1930s Lewis wrote a short polemical essay entitled 'The Role of Line in Art' stating that the line in drawing was nothing less than 'the bone beneath the pulp'. 'It is more difficult upon a piece of white paper,' he wrote, 'your means of expression reduced to a few lines, to deceive the expert spectator than it is with a lot of oil paint upon a canvas.'

If you made a retrospective just of his pen, pencil and watercolour works ending with this image, you'd have a running sequence of astonishment. You'd enter a world where the mix-ups fuse. Here you meet the Lewis hybrid quasi-human – robot, puppet, spirit, design – flying, buried, standing, in formal rows. The quickness of their making gives life to these creatures. They achieve the satirical-mythical synthesis that the oil paintings struggle for.

Drawing frees his art. It makes it lighter, more equivocal, more open to his and our imagination. And we are in the realm of imagination: myth-men, machine-men, historical and futuristic. In any oeuvre, we tend to give priority to the paintings, and treat the drawings as studies, footnotes. With Lewis we should reverse those values. I'm inclined to set him among the English illustrators – the caricaturists and the visionaries – to identify the strong impulse to fiction in his images. Illustration became a very rude word under modern art. But now the spells of twentieth-century Modernism have lost some of their magic. Drawings are where his creativity thrives. He's one of the English graphic masters. Not quite as 'great' an artist as some might wish – but a rarer one.

As he lost his sight, the drawings become ever more metamorphic, visionary, cosmic. Seas, embryos, worlds, thoughts, concatenations of forms that are impossible to grasp. This last, *Red Figures Carrying Babies and Visiting Graves*, is a queue-cum-frieze of shimmering uprights, set in this life or another. It's like Blake of course, and not much else, before or since.

Percy Wyndham Lewis (1882–1957) or 'the Enemy' as he styled himself, was a one-man British avant-garde. Painter, theorist, novelist, poet, magazine-launcher, controversial polemicist (the list goes on), on the eve of the First World War he was the leading figure in Vorticism and an artist of varied genius – a pioneer of dynamic abstraction, a brilliant linear draughtsman, a penetrating portrait painter, a creator of visionary worlds. T. S. Eliot said he had 'the mind of a modern, the energy of a caveman'. He was extremely rude and combative, relentlessly self-publicising, often broke. His reputation has never settled.

Bridget Riley, *Fragments 6/9*, 1965
Screenprint on perspex, 62.5 x 72.1 cm
Tate Gallery, London

Not everything is so straightforward. Next to the hermit are six small blobs delineated by outline. This looks like litter, and it defies you to read it. Could be loose change fallen out of his pocket, pebbles, fluff, pistachios. It must be something. It could be anything. It is all lines.

But at the same time the picture is playing with how lines can tell different things, offering potentially ambiguous or unreadable information. Caulfield very rarely put people in his images, and the figure at the heart of *The Hermit* hardly reads as a person. He is drawn like a boulder. Compare him to the jagged rock on the left. He is blue and it is red but especially if you imagine him being red too, he could be an ambiguous lump, just a bit of funny shaped, bulbous rock, smoothed over time. It's a joke. No single bit of information about him; not a hair or a toe is visible. We see only his cloak. His back is to us. He is a shape like the other shapes. The line that makes him up is identical to the even lines that describe his surroundings.

But the best bit of the picture is what happens in the absence of line. A large section of the image is taken up by the view, and it's a single block of colour. This is what the hermit is contemplating. Just where you might expect a great deal of information, on mountains, trees, rocks or sky, the picture is a complete blank. It tells us nothing. The view from the cave has no lines at all. The hermit's mind has achieved a bright, perfect, yellow blankness. Nirvana. The state of zero line.

Born in south London, Patrick Caulfield (1936–2005) used to be called a Pop Artist. He's really one of the great wits of modern British art. In the early sixties, he developed – from a bit of Léger, a bit of Minoan fresco, a bit of graphic design – a highly economical linear painting style that became proverbial. He often used it to depict the fashionable clean-lined interiors of the period. Caulfield's later work has played with a wide range of styles. He's a clear inspiration to younger painters like Gary Hume. A series of prints, illustrating *The Poems of Jules Laforgue* (1973), may well be his masterpiece.

Dom Sylvester Houédard, *For the 5 Vowels (U)*, 1976
Typewritten material on paper, 30 x 21 cm
British Council

FOR THE 5 VOWELS

Some people hold on to it, but the typewriter, the old manual, is almost gone from our hands and our lives. We went electric, then word-processor, then laptop. In the process, the gap widened from finger to mark. Tangible paper has turned into intangible screen (and ink need never emerge at all). Yet, in the meantime, we still haven't thrown away our pens. And so on our desk today there lies an open chasm: between pure handiwork and the cleanest mechanisation.

Or that's how we often see the distinction, hand against machine. But in *The Nature and Art of Craftsmanship* (1968) the craftsman and teacher David Pye defined the difference more accurately. The contrast, he said, was between 'the workmanship of risk' and 'the workmanship of certainty'.

Almost all workmanship employs tools or machinery (and hands). The question is the relationship between means and end. How far can the precise form of the work be guaranteed? How far will there be some play in it, making the result risky, unpredictable?

Pye said: 'The most typical and familiar example of the workmanship of risk is writing with the pen, and of the workmanship of certainty, modern printing.' The computer page – non-printed, immaterial – would only be a further advance in certainty, another move in the direction away from handwriting

Around the time that Pye wrote his enlightening book on craftsmanship, the poet and Benedictine monk, Dom Sylvester Houédard, was turning the manual typewriter into a visually creative medium. His works offer an object lesson in art and certainty and risk. He called these typed pages 'typestracts'.

Pye mentions the typewriter too. He considers it 'an intermediate form of workmanship, that of limited risk. You can spoil the page in innumerable ways, but the n's will never look like u's, and however ugly the typing, it will almost necessarily be legible.'

That's true, if you use the machine in the standard way. But if you type an n, take the page out, put it in upside down and type a u, they will look very similar. And if you fill a page with typing, then put it in again and type over it, legibility will start to go. This is the kind of way Houédard proceeded.

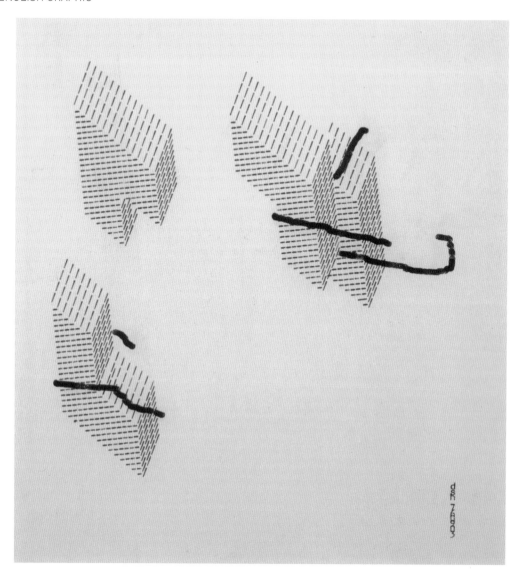

Dom Sylvester Houédard, *For the 5 Vowels (O)*, 1976
Typewritten material on paper, 30 x 21 cm
British Council

He used the manual machine more manually than most, and beautifully.

He employed standard equipment. His typestracts were all typed on a portable Olivetti Lettera 22 (a fact, he said, Olivetti showed no interest in). He limited himself to the normal ink ribbons, with their normal colours, along with various coloured carbon papers too.

Houédard's workmanship combines Pye's categories. He uses the typewriter's 'certainty' elements. There's the fixed hold of the page, the set spacing between characters, the straight and parallel alignment of the lines. There's the fact that all his marks are struck with his machine's available eighty-six key heads.

He also exploits the typewriter's 'risk' elements, the source of what (by strict secretarial standards) would be considered failings, slips and spoils. The keys can be struck with variable pressure. The ink ribbons fade. The roller can be disengaged, the page moved freely through it or reset at a different angle. Keys can be repeatedly overprinted.

Houédard's visual repertoire is as wide as his medium allows. Some of his typestracts are made with the letter keys, and composed from words. Some have the graphic keys – the dashes, the dots, the brackets – doing most of the work. Typestracts can be abstract indeed, flat shimmering surfaces, in which areas of colours of different intensity mesh and blend. Or they can use their strokes to construct quasi-images, often three-dimensional forms.

For the 5 Vowels (U) is like that. It comes from a group of five images, each one a variation on the shape of a vowel. Here, the letter U is translated into a straight-edged solid, a two-pronged structure. It's reminiscent of a tower block or a tuning fork.

A letter is an obvious enough subject for typewriter art, but there aren't any u's or other letters used in this U-structure. Its planes are made entirely from full stops, more and less widely spaced. These dots are in regular lines and columns, and most of them are set on the page in the normal upright way, and very tightly.

But the dots that form the wider-spaced, up-facing planes run at diagonals. Houédard didn't do this freehand. He turned the page in the machine, and used

stencils to guide his slanted forms. In other words, he added some extra 'certainties' to the typewriter's built-in regularities.

The two-pronged U-structure seems to be floating off the ground, or rather just above a separate oblong base. (It could be a three-dimensional underlining.) The U-structure is typed in brown ink, but this base is in green, and it's constructed not from dots but from a stitching and criss-cross of dashes.

What makes the U-structure look weightless is the way it's joined to this base. A length of string, knotted around the ends of the base, and threaded through the U, is holding it down.

Now this length of string *is* a piece of freehand drawing (though very laborious). It is created by gradually moving the page by hand through the roller, as numerous individual black strokes are closely overprinted and accumulated into a loose, fat, twisted line.

The strokes are so dense, so merged together, it's a little hard to identify which key has been used to make them, but probably it's the capital O. And they're struck with a degree of 'risk' – an uncertainty as to where they will exactly land on the page – that's beyond even the messiest typist or the jerkiest machine. This imprecision imbues the knotted string with its fluid or organic character.

There are other drawn lines, but thinner and shorter. They hang on the tops and sides of the U-structure. They're probably made from dots. They look like seaweed trailing down it, or sea-worms slithering up it. There are further tiny drippings or droppings or beadings, descending and going off the bottom. All these marks give the U-structure a feeling of being underwater. That makes sense of its weightlessness. Perhaps that's what U stands for.

By turning the typewriter to these novel purposes, this typestract uses it both with and against its grain. It employs its existing regularities and vagaries, and then introduces new ones. Some of these are very alien to a typewriter's habits – like the exact but oblique alignments, or the free drawing. But they're combined with normal typing practices, like the lines of dot dot dots The familiar only makes the strange seem stranger.

The typestract shows a medium being put through its paces, and a body being put through a machine. It sets certainty in dialogue with risk, painting with text. It stresses typewriting as motion. As dsh wrote: 'typestracts – rhythm of typing – action poetry.'

Dom Sylvester Houédard (1924–92), priest, scholar and avant-garde poet, preferred to spell himself in lower case – and signed himself simply as dsh. He was a unique figure in British culture. Born in Guernsey, he worked in British Army Intelligence, and joined the Benedictine Prinknash Abbey in Gloucestershire. In 1959 he was ordained. He became literary editor of the Jerusalem Bible (the Catholic English translation), and wrote theological works on Meister Eckhart. At the same time he was a leading figure in the British wing of the Concrete Poetry movement. As well as numerous shape poems and typestracts (the name had been coined by the Scottish poet Edwin Morgan), he invented the beautiful palindrome 'drawninward' (it reads both ways, but it's drawn inward to the 'i' at its centre) and the brilliant word turnover 'deus/snap' (in which God snaps himself). He worked on the borderlines of western and eastern spirituality, and of Christianity and modern art. He said: 'inevitably I feel my own work as the continuation of the tradition of benedictine poets and artists . . .'. He needs to be recalled.

We lived beneath the mat
Warm and snug and fat
But one woe, & that
Was the cat!
To our joys
a clog, In
our eyes a
fog, On our
hearts a log
Was the dog!
When the
cat's away,
Then
the mice
will
play,
But, alas!
one day, (So they say)
Came the dog and
cat, Hunting
for a
rat,
Crushed
the mice
all flat,
Each
one
as
he
sat,
Underneath the mat,
Warm, & snug, & fat – Think of That!

INDEX

Numbers in *italic* refer to captions

Alberti, Leon Battista 128
Albion Rose (or *Dance of Albion* or *Glad Day*) *122*, 123–5
Alice in White Rabbit's House *156*, 158
Alice Overgrowing the Room *156*, 157–9
Allais, Alphonse 161
Ambleside 78, 79–81
The Ancient Britons 113
The Ancients 140, 147
An Angler with his 'Set Gads' on a Riverbank 127
Arp, Jean (Hans) 176
Art Nouveau 163

Bacon, Francis 176
Banks, Thomas 61
Bateman, Henry Mayo *174*, 175–7
Baudelaire, Charles 115
Bauhaus 79–80
Beardsley, Aubrey 109, *160*, 161–63, *164*, 166–7
Beck, Harry *178*, 179–81
Beddoes, Thomas Lovell 119
Beerbohm, Max *164*, 165–7
de Bello, Richard *24*, 25–7
Bennett, Alan 191
Berger, John 139
Bewick, Thomas 127–37, *207*

The Bishop's Eye 32, 33–5
Blake, William 41, 62–5, *63*, 73, 75, 77, 109, *110*, 111–25, *112*, *114*, *118*, *122*, 127, 140–41, 145, 147, 158, 173, 185
Blasted Tree and Blighted Crops 127
A Blot: Tigers 68, 69–71
Borges, Jorge Luis 187
Bosch, Hieronymus 45, 83
Bosse, Abraham *40*, 41–3
Browne, Thomas 57
Brunhild Watching Gunther Suspended from the Ceiling on their Wedding Night 64, 65
Burton, Dr John *56*, 57

Callot, Jacques 43
Carroll, Lewis 41, *156*, 157–8, *207*
Carwitham, Thomas *48*, 49–51
Caulfield, Patrick 109, *190*, 191–3
Cézanne, Paul 85
Characters and Caricaturas 52, 53–5
Chardin, Jean 74
Chesterton, G. K. 39
Christ Offers to Redeem Man 114

Chronicle of England 28, 29–31
Clarkson, Thomas 22, *86*, 87–9
Classical Outlines 106
Coleridge, Samuel Taylor 57, 80, 81
Committee for the Abolition of the Slave Trade 22–3, *86*, 87–9
Concrete Poetry 199
Constable, John 59, 140
Correggio, Antonio 113
Cozens, Alexander 61, 68, 69–71, 75, 129
Creation of Adam 67
Cruikshank, George 41, *148*, 149–51
Cubism 35, 183–4

The Damned are Swallowed by Hellmouth 20, 21–3
Dante Alighieri 22, 50, 62, 88, 109, 153, 169
David, Jacques 109
A Democrat or *Reason and Philosophy 102*, 103–105
Disney, Walt 25
Dixon, James 155
Drawing for the Bright Cloud 142
Dürer, Albrecht 140, 147

Early Morning 138

Eckhart, Meister 169, 199

Egg, Augustus 157

Electra and the Chorus bearing
Vessels for Libation on the
Tomb of Agamemnon
106, 107–109

Eliot, T. S. 149, 185

An Essay towards a Complete
New System of Midwifery
56, 57–9

Expressionism 83

The Face of the Moon 94, 95–7

Fantasy of Flight 48, 49–51

A Fantasy: The Fairy Ring
148, 149–51

Fauvism 145

The First Book of Urizen 110,
112, 115

Flaxman, John 62, 75, *106*,
107–109, 169

The Flea 44, 45–7

folk art 155

Fontana, Lucio 172

For the 5 Vowels (O) 196

For the 5 Vowels (U) 194,
195–9

A Foregathering of Witches 72,
73–7, *74*, *76*

Fox, Charles James 104–105

Fragments 6/9 186, 187–9

Frankenstein 61–7, 66

Fraser, George 139

Friedrich, Caspar David 80

Fuseli, Henry *60*, 61–7, *64*, 75

Futurism 175

Gainsborough, Thomas 59,
73, 77

Gauguin, Paul 141

Gillray, James 62, 75, 92–3,
98, 99–105, *102*, 151, 159

Giotto 17

van Gogh, Vincent 147

The Good and Evil Angels 63

Gould, Glenn 175

The Gout 98, 99–101

Goya, Francisco de 42, 77,
109, 115, 165

Grandma Moses 155

El Greco 23, 83, 145

Grünewald, Matthias 45

Hall, James 107

Hazlitt, William 153–4

The Hermit 190, 191–3

Hilliard, Nicholas *36*, 37–9

Hobbes, Thomas *40*, 41–3, 45

Hogarth, William 51, *52*,
53–5, *204*

Holbein, Hans 157

von Holst, Theodor 65–7, *66*

Hooke, Robert *44*, 45–7

Houédard, Dom Sylvester
194, 195–9, *196*

Hughes, Robert 165

Hume, Gary 193

In a Shoreham Garden 144,
145–7

James, Henry 167

Jerusalem the Emanation of
the Giant Albion 117,
118, 119–21

Johnson, Samuel 89

Keats, John 103–104

Klee, Paul 79–81

Lear, Edward 41, 167

Léger, Fernand 25, 193

Lely, Peter 47

Leviathan: The Matter, Forme
and Power of a Common
Wealth Ecclesiasticall and
Civil 40, 41–3

Lewis, Percy Wyndham *182*,
183–5

Locke, John 134

The London Underground
Map 178, 179–81

Long, Richard 140

Malevich, Kazimir 171

Manet, Édouard 191

Map of England, Scotland
and Wales 28, 29–31

Mappa Mundi 24, 25–7

Massys, Quentin 157

Matisse, Henri 18, 75, 165

Michelangelo 58, 62, 67,
105, 113, 125, 172

Micrographia, or some
Physiological Descriptions
of Minute Bodies made by
Magnifying Glasses 44, 45–7

Mill, John Stuart 187

Millais, John 157

Milton, John 30, 111

Mirò, Joan 176

Modernism 85, 141, 147, 173, 176, 179, 183, 185
Mondrian, Piet 179
Monet, Claude 145
Mr Aubrey Beardsley 164, 165–7
Murray, Les 150

Nash, Paul 141
Navicella 17–18
A New Method of Assisting the Invention in Drawing Original Compositions of Landscape 69–70
The New Word in Golf 174, 175–7
Newton, Richard 62

Op Art 189
Outsider Art 75

Palmer, Samuel 127, *138*, 139–47, *142*, *144*
Panofsky, Erwin 107
Paris, Matthew *28*, 29–31
Pedagogical Sketchbook 79
Picasso, Pablo 18, 77, 125
Pilori, Thomas *106*, 107
Piranesi, Giovanni 65
Plutarch 17
Pop Art 189, 193
Portrait of Himself in Bed 160, 161–3
Portrait of its Immanence the Absolute 168, 169–71
Portrait of an Unknown Man Clasping a Hand from a Cloud 36, 37–9

Potter, Beatrix 41
pre-Raphaelites 143, 163
Prometheus 60, 61–2
Pye, David 195–7

Racine, Jean 45
Raphael 53, 113
Red Figures Carrying Babies and Visiting Graves 182, 183–5
Rembrandt 77
Renaissance 109, 125, 128, 169
Reynolds, Joshua 59, 73, 77
Riley, Bridget *186*, 187–9
Rococo 93, 163
Romanticism 61, 73, 80, 85, 139, 147
Romney, George 62, *72*, 73–7, *74*, *76*
Rosa, Salvator 157
Rosen, Charles 131
Rosenblum, Robert 107
Rousseau, Henri 155
Rowlandson, Thomas *90*, 91–3, 153
Rubens, Peter Paul 113
Ruskin, John 143
Russell, John *94*, 95–7

Schubert, Franz 80
Shakespeare, William 31, 62, 70, 74
Shelley, Mary 65–7, *66*
Six Stages of Marring a Face 90, 91–3, 153
Six Stages of Mending a Face 90, 91–3
Sontag, Susan 99

The Source of the Arveiron 82, 83–5
Sower of the Systems 170, 171–3
Stowage of the British Slave Ship 'Brookes' under the Regulated Slave Trade Act of 1788 23, *86*, 87–9
Stubbs, George *56*, 57–9
Surrealism 83, 176
Sutherland, Graham 84, 141
Swift, Jonathan 30

Tenniel, John 41, *156*, 157–9
Thornton, Robert John 127
Titian 113
Totius Britanniae Tabula Chorographica 28, 29–31
Towne, Francis *78*, 79–85, *82*
Turner, J. M. W. 59, 145

The Uffington White Horse 16, 17–19

da Vinci, Leonardo 30, 47, 69, 159
Vorticism 175, 185

Wallis, Alfred 155
Watts, G. F. 169–73, *170*
West Bromwich Sweep 152, 153–5
Winchester Psalter *20*, 21–3
Wittgenstein, Ludwig 165
Wren, Christopher 47

Zerner, Henri 131

William Hogarth, *Self portrait* (detail), 1749
Engraving, 37 x 27 cm
Private collection

EDITOR'S NOTE

Tom assembled a working schedule for the publication of *English Graphic* in the second half of 2010. As is clear from the richness of the material, it was a project dear to his heart. The subject had been in his head for a long time and had he lived longer he would have organised the work into a book. 'Arguments in Shape and Line' was an early sub-heading. But in 2008 he was diagnosed with a brain tumour in the area of speech and language. He continued to work as art critic for the *Independent* until September 2010.

I added five essays from an earlier, expanded list he had compiled for *English Graphic*: *The Uffington White Horse*, *The Bishop's Eye*, Hilliard, *Portrait of an Unknown Man Clasping a Hand from a Cloud*, Russell, *The Face of the Moon* and Cruikshank, *A Fantasy: The Fairy Ring*. I have also included the pieces on Romney, Rowlandson, *Mending a Face / Marring a Face* and Bateman, *The New Word in Golf*.

Tom's 2010 schema was unfinished and loosely thematic, but on looking at the material it made sense to make the book chronological and allow the many themes to thread through the text. As all the essays were first published separately, there were overlaps from one piece to another, some of which I have allowed to stand.

The majority of the essays in *English Graphic* first appeared in Tom Lubbock's Great Works column published in the *Independent* between 2005 and 2010.

The following essays were first published as reviews in the *Independent*:
Fuseli to Frankenstein, *Gothic Nightmares: Fuseli, Blake and the Romantic Imagination*, Tate Britain, 2006, *A Foregathering of Witches*, *George Romney: British Art's Forgotten Genius*, Walker Art Gallery, Liverpool, 2002, *Vision and Landscape*, *Samuel Palmer: Vision and Landscape*, British Museum, 2005-6. *Defining the Vignette* was a catalogue essay commissioned to accompany the exhibition *Thomas Bewick: Tale-pieces* at the Ikon Gallery, Birmingham, 2009.

The following essays are previously unpublished:
Rowlandson, *Mending a Face / Marring a Face*, *Blake Shapes*, Lewis, *Red Figures Carrying Babies and Visiting Graves*, Riley, *Fragments 6/9* and Caulfield, *The Hermit*.

Marion Coutts
April 2012